LUZON

PALAWAN

MINDANAO

P

N E S

SABAH

EI

MANTAN
NESIAN
RNEO)

SULAWESI

E S I A

BALI

D0687390

IMAGES OF ASIA

Sarawak Crafts

Titles in the series

Sarawak Crafts

Methods, Materials, and Motifs

HEIDI MUNAN

OXFORD

UNIVERSITY PRESS

OXFORD

UNIVERSITY PRESS

4 Jalan Pemaju U1/15, Seksyen U1, 40150 Shah Alam,
Selangor Darul Ehsan, Malaysia

Oxford University Press is a department of the University of Oxford.
It furthers the University's objective of excellence in research, scholarship,
and education by publishing worldwide in

Oxford New York

Athens Auckland Bangkok Bogotá Buenos Aires Calcutta
Cape Town Chennai Dar es Salaam Delhi Florence Hong Kong Istanbul
Karachi Kuala Lumpur Madrid Melbourne Mexico City Mumbai
Nairobi Paris São Paulo Shanghai Singapore Taipei Tokyo Toronto Warsaw

with associated companies in Berlin Ibadan

Oxford is a registered trade mark of Oxford University Press
in the UK and in certain other countries

Published in the United States
by Oxford University Press, New York

© Oxford University Press 1989
First published 1989
Third impression 2000

ISBN 019 588899 5

Printed by KHL Printing Co. (S) Pte. Ltd., Singapore
Published by Penerbit Fajar Bakti Sdn. Bhd. (008974-T)
under licence from Oxford University Press

Acknowledgements

I would like to record my thanks to the Director, Sarawak Museum, for permission to quote from 'Prayers for the Erection of a New House', 'Kelabit Hero Song', 'Bidayuh Women's Prayer', and 'Iban Love Song', and for the use of a number of photographs, and to the Director, Dewan Bahasa dan Pustaka (Sarawak) for permission to quote from *Pengap Gawai Batu*.

Plates 4 and 11 are reproduced by kind permission of the Trustees of the British Museum.

I am much indebted to Dr Paul Chai of the Sarawak Forestry Department who checked all the botanical information in the chapter on Materials, to Hedda Morrison for her classic Sarawak photographs, and to Susi Heinze for line-drawings illustrating technicalities beyond my descriptive powers.

I would also like to thank all the friends who read parts of the manuscript and offered suggestions for improvement, and helped with illustration research.

All photographs in the book are by the author unless otherwise stated.

Kuching, Sarawak HEIDI MUNAN
1988

Note on Population

SARAWAK'S population was 1,307,000 at the time of the last census in 1980. Of the total, 30.3 per cent are Iban ('Sea Dayak'), 29.5 per cent Chinese, 19.7 per cent Malay, 8.2 per cent Bidayuh ('Land Dayak'), 5.7 per cent Melanau, 5.3 per cent Other Indigenous (Orang Ulu), and 1.3 per cent Others.

The Malays were traditionally coastal and estuary dwellers, farmers, fishermen, and traders. During the Brooke era they made up the core of the native civil service. Today they are found in all trades, professions, and industries.

Some Malays trace their descent to Sumatra and the Malay Peninsula, others to Brunei. The cultural bond uniting all Malays is their religion, and until fairly recent times even a Bidayuh or a Melanau who embraced Islam would start to wear Malay dress and consider himself a Malay.

The Chinese, most of whom have immigrated within the last 150 years, are mainly shopkeepers, traders, and businessmen. Others are professional people, teachers, and civil servants. The majority of Sarawak's potters are Teochew Chinese.

The middle and upper reaches of Sarawak's major rivers are the home of the people once called 'Dayak'. 'Land Dayaks', properly called Bidayuh, were probably one of the original groups to inhabit Borneo. Many of the souvenirs offered for sale around Kuching are of Bidayuh manufacture.

The 'Sea Dayak', now called Iban, are found in all parts of Sarawak. Many are still farmers, cultivating dry or irrigated rice, cash crops, or large land estates.

The Melanau people now live mostly in the coastal areas between the Rejang and the Baram Rivers. Many Melanau are now Muslims or Christians.

The people from the highlands of Central Borneo are collectively called 'Orang Ulu' for convenience, not because there is any ethnographic justification for the term. The major Orang Ulu groups are the Kayan, Sekapan, Kejaman, Kenyah, Kajang, Berawan, Lun Bawang, Lun Dayeh, Kelabit, and the scattered Penan. What they have in common is their homeland among the upper reaches of Sarawak's major rivers, strongly stratified social systems, and remarkable artistic ability.

Contents

Introduction

ABOUT one-sixth of the great island of Borneo is taken up by
Sarawak, a territory carved by the vagaries of nineteenth-
century politics. Once part of the Sultanate of Brunei, the
English gentleman-adventurer James Brooke had the western
part of the present State leased or ceded to him in 1841. His
successors expanded the territory at the expense of their nom-
inal overlord until it reached its present size in 1902.

History thus explains Sarawak's ethnic diversity. An area of
124,449 sq km is inhabited by some thirty—or, if local distinc-
tions and sensibilities are taken into account, more—native
groups, all of whom have cousins in Sabah, Brunei, and Indo-
nesian Borneo.

The boundaries between these countries were drawn by
officials in London and Amsterdam. To the inhabitants of
Borneo, however, lines on maps meant nothing whatever
until quite recent times; thus it is impossible to treat of indigen-
ous Borneo culture within their confines. A fine example of
Kenyah carving may be from Sarawak or Indonesia, a length
of Iban textile from Sarawak, Indonesia, or Brunei.

The student of Borneo meets the term 'Dayak' or 'Dyak' at
an early stage. It is a Malay word describing the non-Muslim
natives of Borneo and Celebes, adopted as a useful term by the
colonial administrator who wanted to make it clear that he was
not speaking about the Malay or Chinese inhabitants of his
District. English writers generally distinguish between Land
Dayaks and Sea Dayaks while giving the central Borneo people
their proper names—Kayan, Kenyah, Kelabit, and Penan,
among others.

Referring to everybody by their proper names can, how-

ever, be difficult. Under 'Kenyah', the 1960 Census of Sarawak included eight separate groups, under 'Melanau' a splendid sixteen! The modern term for 'Land Dayak', Bidayuh, is only grudgingly accepted by people who fall under its definition but who are *not* Bidayuh; the name 'Orang Ulu' (upriver people) for Kayan, Kenyah, Kelabit, Penan, Murut, and other highlanders is being severely questioned by its bearers. The Sarawak Murut are not in fact called Murut, but Lun Bawang.

This book describes the material culture of those Borneo people found in significant numbers within the East Malaysian State of Sarawak. Reference is made, for the most part, to their simplest or best-known names. Most illustrations are drawn from Sarawak sources since the Sarawakians who carve, weave, plait, smith, and paint are the ones the author knows, has observed, and has tried to learn from. The selection is not meant as a judgement of quality. The heritage they all share is Borneo-wide and its sources are beyond the island.

Traditionally, most Borneo people lived in longhouses, a village, including the main street, under one roof. Much labour was devoted to the erection and embellishment of these massive structures. Depending on farming habits, longhouses were built to last but a few seasons, or for several generations. This form of dwelling ensured the community's safety and permitted access to a maximum number of relatives at all times, weather notwithstanding.

The post-War trend among some people is for individual family houses. Others still prefer the longhouse, though they may build it of sawn timber, with glass windows, indoor plumbing, and electric light.

There are modern trends in all aspects of Sarawak life. It is neither reasonable nor just to expect that an unspoilt jungle paradise be preserved here for the edification of spectators by the same definition spoilt! Sarawak has opted for parliamentary democracy, formal education, motor transport, mass media,

commercially produced consumer goods, and modern medicine. Far from seeing the Civil Service as a foreign imposition, to have a son or daughter 'eat a Government wage' is a dream come true for respectable Sarawak families.[1]

Sarawak native crafts are still being made. New materials are used and new tools are eagerly welcomed–chisels and gouges, saws, emery paper, and even shoe-black to make a softwood statue 'instant hardwood'! Aged weavers continue to turn out masterpieces, thanks to spectacles; fine jobs are done after nightfall, thanks to the electric light. New motifs are adopted to suit the demands of the market, the availability of materials, and the craftman's fancy.

There is no longer a need to produce all necessities of life within the family unit. Artefacts are made for home consumption if shops are too far off, or if shop-bought articles are too dear or not to the consumer's taste.

A budding cottage industry now produces crafts for the tourist market: basketry, mats and hats, woodcarving, weaving, and decorative bamboo containers and utensils.

Fine old artefacts must be considered the test and inspiration for today's workers, but not the limit. A resurgent pride in Sarawak's heritage is breeding a new generation of craftsmen, young men and women who create things of use and beauty, not in between other more important tasks but as their main interest and avocation. They will reject what is false and contrived among the new trends, and find new meanings in old models. This book is dedicated to them.

[1]For a detailed treatment of this and related points, see P. M. Kedit, *Modernisation among the Iban of Sarawak*, Dewan Bahasa dan Pustaka, Kuala Lumpur, 1980.

I

Carving

He carves a sheath for his *parang*
Carved from heartwood, red and bright
A *parang* sheath in the hand of Lord Balang Lipang
A sheath shaped like a fishtail, two fins at the bottom.
Carved on the sheath with the tail of an animal
Is a leopard with overhanging fangs
One tooth as big as both arms around.

Kelabit hero song[1]

THE natives of Sarawak like the security of the longhouse but they are equally at home in the jungle. Many of them were once nomadic, as some Penan still are. In the days before extensive contact with other cultures, all derived their livelihood from the jungle.

Food is hunted and fished from the jungle, or planted on clearings borrowed for a time from the jungle. The many materials used for making mats, containers, hats, clothing, and shelter—all the necessities of life—come from the jungle.

The jungle, personified by a big tree, is seen as a spirit, a presence, a friend, or an enemy depending on how man approaches it. The Iban used to place a blowpipe beside a jungle giant about to be felled and laid an offering spread on a length of precious handwoven textile on the stump afterwards. The Bidayuh inform the trees that they are about to be felled and present gifts to their spirits. Most farmers only fell a few boles on the first day and then return to their homes, giving the silvan gods time

[1]Rubenstein, Carol, 'Poems of Indigenous Peoples of Sarawak', *Sarawak Museum Journal*, special issue, Vol. 21, No. 42.

to move out before land-clearing starts in earnest. Omission of these important rites may lead to accidents during the felling.

Special taboos and language are observed by jungle produce collecting parties and often by hunters. The jungle is tolerant of the respectful intruder, but it can play havoc with the over-confident.

Woodcarving for Magic

Something of the respect for the jungle is carried over into the production of woodcarving, which makes use of the trees' very limbs. Few aesthetically pleasing artefacts are carved without a thought to ritual or magical significance. Indeed, some ritual and magical objects are wrought with no consideration other than to please the spirits for whom they are intended. Or to frighten them! Some Bidayuh sculptures of human figures, placed along the path to a longhouse, are considered ugly by artistically sensitive observers, and so they are. Roughly hewn blocks with prominent genitalia are strategically placed to frighten away sickness or evil spirits, themselves sexless and thus baffled by those peculiar appendages. Such statues are *meant* to be ugly.

Many old Iban longhouses have similar figures, often with ambiguously grinning faces, placed near the top of the steps leading to the outer platform. These are guardians as well as repellents. Songs mention them as familiar faces which 'smile' at a returning traveller who is glad to see them after his arduous journey. They may be very basic; some do not even have legs but are simply a post with a quasi-human face at the top.

Orang Ulu houses may have faces carved into the main house posts, the ladders, and particularly the stairheads. Some communities populate the immediate surroundings of the longhouse with protective deities carved on tall posts. Certainly no tomb hut would be complete without them.

The famous Borneo ghost masks (Colour Plate 1), sometimes used in hilarity and horseplay, originated as disguises designed to drive away evil. They could protect the wearer, too. Formal welcomes to longhouses were sometimes performed by a masked man. This kept a certain distance between settlers and guests that would be gradually overcome by ceremonial speeches and libations. Until then, the chief host did not want to be recognized; his tribal deities, as represented by the masks, both greeted the visitors and warned them against possible transgressions of the law of hospitality.

The scout investigating a group of genuine strangers coming up to the longhouse might wear a mask, too, for the same reason.

More often, the masks were used in festivals connected with the *padi* cult. They were intended to drive away sickness, poverty, poor growth, agricultural pests, and bad harvests which were believed to be caused by wicked spirits who would not pay much attention to a mere human trying to scold them into better behaviour. A mask convinced them that they were dealing with an equal, a power as supernatural and thus as potentially mischievous as themselves.

Some Iban went to the trouble of fashioning masks of hardwood although most Central Borneo specimens are carved of softwood which is much easier to work and produces a lighter artefact, more comfortable to wear.

Masks have grotesque but usually humanoid faces, though the Kenyah and Kayan occasionally shape the *aso*, the stylized dragon-dog, or a daemonic pig. Some masks, for instance the few surviving Bidayuh ones, are crudely carved, the work of a few hours. Others are elegantly finished with three-dimensional scrolls, noses, and fangs. Some have very elaborate ears which are carved separately and lashed to the sides of the mask with rattan strings.

Nearly all masks are painted to heighten their effect. The traditional colours were red, white, and black, applied with

the fingers on large areas and with chisel-shaped sticks for filling in detail.

Woodcarvers were often called on by the magician to make an effigy of an object or person. The coastal Melanau, for instance, produced a whole range of 'sickness spirits' called *blum* or *dakan*, images quickly carved out of softwood or even sago pith when the need arose (Plate 1).

These hasty productions were surprisingly beautiful and detailed. A sickness spirit had to have the correct characteristics and attributes so that it could be readily recognized. Arm position, headgear, facial expression, and clothing indicated which of the many spirits the *blum* was supposed to represent. Indeed, doctor and carver had to co-operate closely or the patient might be cured of the wrong disease!

After elaborate ritual the sickness spirit was reverently and ceremoniously placed in a gaudily decorated, fully outfitted

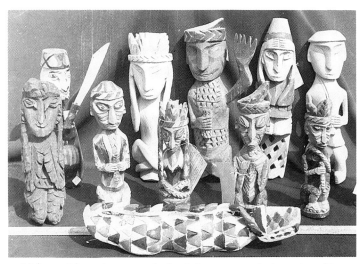

1. Melanau sickness images ready for their one-way trip downriver (Photograph Sarawak Museum).

model boat, and launched on a downriver journey from which it was piously hoped it would not return.

A sickness image could not be used twice. It had to be ritually discarded, either by sending it away or, less commonly, by throwing it in the jungle. No wayfarer would ever touch such an offering; 'genuine antique Melanau *blum*' which occasionally appear on the market should be treated with scepticism.

An image could also be made of a relative missing at sea if the body had not been recovered. It was carved like a *blum* and carefully endowed with the physical characteristics of the departed.

Such obsequies were not held at short notice. What family of a lost sailor gives up hope? Melanau seafarers have almost miraculous survival powers and are sometimes found after weeks of drifting in a rudderless vessel or on a makeshift raft, or stranded on one of the uninhabited islands that dot the coast around Brunei Bay and up towards Sabah. This image could be ordered well in advance of the ceremony and finished with care.

Lodging the effigy in a pretty model house made of palm leaves, the bereaved family held a wake for it and finally buried it in the local graveyard.

The Bidayuh in West Sarawak have their own method for sending illness out to sea. A priestess must have a bird-shaped wooden box, a *mapu*, hung around with beads, bells, and tiny carved swords and paddles, in which she keeps her magic paraphernalia (Plate 2). When an illness has been captured, it is put into the box. The lid is quickly shut and the whole container hung on the front verandah facing the distant sea, or more specifically Mt Santubong, a peak in the Sarawak River estuary that is visible for miles inland. The bird flies there and invites the sickness spirit to propel itself out to sea with the paddles provided.

This magic box has been made for the priestess by her men-

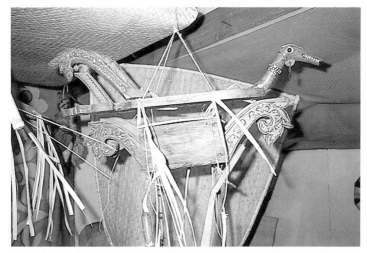

2. Bird-shaped *mapu*.

folk but once it has been dedicated to its ritual use, no man is allowed to touch it at risk of severe penalty.

The Iban make an effigy of a hunting deity, familiarly addressed as 'Buat', to preside over their pig traps (Plate 3). This worthy can attract wild animals which are then impaled by deadly spears set on strong springs. Its figure, the *tuntun*, is mounted on a stick which indicates the height of the trip-wire and thus warns passers-by. Although the owner of a field makes it known throughout the longhouse where his traps are set, accidents do happen. In heavily populated areas, traps are not much used any more. Game–deer as well as pigs–is more scarce, and traps are simply too dangerous to ignorant wayfarers.

The image of the *tuntun* is a compact figure of a human or monkey, crouched, supporting its head on its hands, with tightly flexed legs pressed by tightly flexed arms. It has an alert expression, elongated features, and protuberant eyes. It is carved with care, whittled out to free round limbs from the cylindrical block of the body.

6

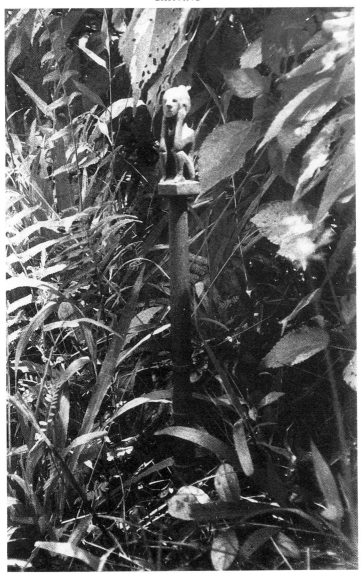

3. Iban hunting deity to bait pig traps.

Tuntun are made of strong iron-wood. They are meant to last, to withstand weathering so as not to lose their characteristic appearance and thus lose their essential functions, both attractive and repulsive.

Iban woodcarvings sold as souvenirs are often based on the model of the old pig trap charm, and are either deliberately produced to look like the genuine article or adapted. Human figures carrying loads, doing household and farming tasks, and paddling boats frequently have that simian look associated with Buat.

The most famous Iban carving is the *kenyalang*, the hornbill effigy made for an elaborate festival celebrating high achievement (Colour Plate 2).

Older hornbill images are made of dark wood, the only decoration being rich carving. Newer ones are carved of softwood and painted in many colours.

The real hornbill's basic outline is realistically observed: the bird has a disproportionately long, heavy beak, a squat body, and straight tail feathers about as long as the body.

The carved *kenyalang*'s head and beak stretch forward and upward, while the casque is represented by fancifully involved scroll work. The beak often ends in a *glans penis*, graphically finished, emphasizing an essentially masculine festival. The middle or body portion is solid, to balance the two extremities. The tail is covered with decorations either of a symbolic or a very realistic kind. On hornbills made within the last fifty years, men on horseback and on bicycles, tumblers and acrobats, soldiers or the Rajah's police in uniform, may be found. The whole artefact is embellished with oil paint in all colours of the rainbow.

The *kenyalang* is further decorated with strings of beads or chains of silver around its neck, colourful streamers, or shreds of the old Sarawak flag (the new ones, it is reported with regret, are quite useless for magical purposes). When a hornbill is carried

from door to door in the longhouse, gifts of cash and in kind are lavished upon it. These may be banknotes elegantly folded, speared on thin sticks to make flags, or twisted into little cones like *sireh*[2] quids prepared for an offering.

The main function of the *kenyalang* is to 'fly' to an enemy longhouse and put all its warriors out of commission. This is achieved on a set day of the festival, when the effigies are taken out of the house and fixed on tall poles on the verandah, pointing in the direction of their attack. The enemy will be overtaken by giddiness, blindness, or any number of other weaknesses gleefully described by the owners of the *kenyalang*, and will certainly be vanquished without much trouble during the next raid.

Woodcarving for the Departed

Some of the most spectacular woodcarving in Sarawak was produced to embellish tombs and ossuaries.

In most communities, earth burial, exposition, or cremation was the means of disposing of a slave's or a commoner's body. The high-ranking, however, were enshrined in monuments that could be seen far and wide.

The Melanau, the Kelabit, and some other Orang Ulu carved massive tomb posts called *keliring* (Colour Plate 3) in some regions. The body of the deceased would be deposited in a coffin or a jar inserted into a slot several metres above the ground, or on a platform at the top. Sometimes bones only were treated to secondary burial in a post.

The work of making a *keliring* took many highly skilled man-hours. The post had to be deeply carved along its entire height. It usually featured faces or whole figures near the top

[2]*Piper betle*, a leaf traditionally chewed with betel-nut and lime as a stimulant in many South-East Asian societies.

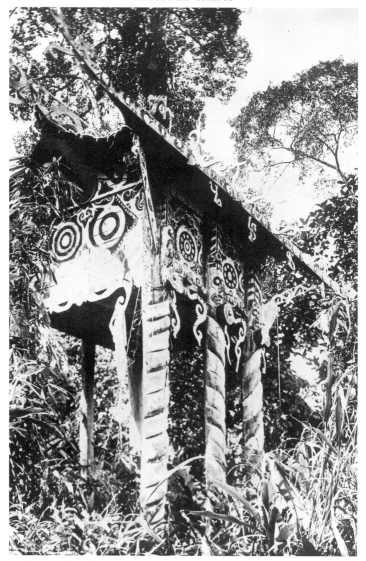

4. Tomb of a Sekapan chief photographed by Dr Charles Hose (Courtesy of the Trustees of the British Museum).

and animals, curved lines, and ropes at the lower levels. As a sign of wealth, some of the knobs which formed part of the design were capped with porcelain rice bowls or ceramic plates. These had to be perforated before they could be fixed to the wood, an operation which usually resulted in considerable wastage which only the rich could afford. A German firm is reported to have produced large dinner plates with a hole in the centre for export to Borneo, ordered by an enterprising Dutch trader in the nineteenth century.[3]

Another kind of monument was the *salong* or tomb hut (Colour Plate 4, Plate 4), a structure raised on high pillars, containing either whole coffins or jars used as ossuaries. These were often painted as well as carved, but the roof ridge and eaves inevitably featured intricate carving. They were often painted as well, but years of exposure to the elements faded the surface-applied decorations. The dragon-dog guarded venerable remains, as did grotesque faces and snake and bird motifs.

Some Kelabit primary burials were placed in a coffin shaped like a long four-footed animal with an elaborately carved head, richly painted. The body was placed within and the lid sealed with jungle resin; a similarly cemented bamboo pipe led to the ground to drain the structure. After a proper interval, the coffin was opened and the bones collected, to be deposited in antique jars in a rock crevice, a cave, or a secret spot in the jungle.

Blowpipes

Most of Sarawak's native groups have used the blowpipe (Colour Plate 5) in the past. All acknowledge the nomadic Penan as masters at making and employing the silent weapon.

A blowpipe is first fashioned out of a piece of straight-grained wood, roughly shaped to a length of about 2 m and a diameter

[3]Cited in Nieuwenhuis, A. W., *Quer Durch Borneo*, Vol. 11, 1907.

5. Making a blowpipe.

of 15–20 cm. Then it is wedged strongly in an upright position within a platform built around it (Plate 5).

The weapon is perforated by means of a long metal rod with a chisel-shaped bit. The rod is moved on its own axis, back and forth, with the bit slowly drilling into the wood. From time to time, water is poured into the hole to float out wood chips. In Central Borneo, baskets containing stones were used to weight the drill rod and place more pressure on the bit once it had got a fair purchase.

When the drilling has been completed, the pipe is trimmed and whittled to a diameter of about 5 cm. The finished weapon is polished with a tough-grained, slightly waxy leaf.

There are records of Muruts drilling blowpipes from *below*, pushing the metal rod upwards by main force.

The bore of the blowpipe is very slightly curved to compensate for the weight of the weapon in use as it is horizontally held. The customary double-edged spear blade lashed to the muzzle end, which makes a serviceable pike out of the blowpipe, also adds weight. The bore is polished by means of pulling lengths of rotan through it.

Blowpipe darts are made of softwood or wood pith, tipped with sharp wood or metal. These may be dipped in poison, dosed according to the size of the quarry.

Bamboo Whittling

Blowpipe darts and the lethal blowpipe poison were carefully carried in watertight bamboo containers, nearly always beautifully decorated with surface whittling (Plate 6).

Not only quivers but all manner of other containers are made of this light, durable, and resilient material (Colour Plate 6). Fire-making implements, tobacco, and small valuables were carried in a bamboo tube; more latterly pens and important letters or documents are stored thus. The Bidayuh like to smoke

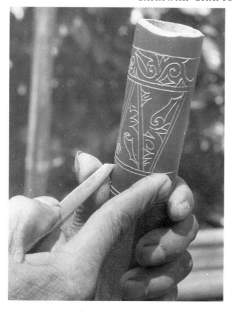

6. Bidayuh craftsman decorating a bamboo container (Photograph Hedda Morrison).

the occasional water-pipe, an article made of bamboo and lavishly decorated if intended for 'parlour use'.

A number of wood-wind instruments are made of bamboo, too. The Kelabit and Lun Bawang of East Sarawak are adept at making whole orchestras of consorting flutes and a bass, best described as a bamboo bassoon, with which they play a large assortment of tunes. A species of bamboo bagpipe also exists, a large gourd-bellows with harmonically tuned pipes standing up in an organ-like formation of six or eight.

Bamboo utensils are decorated by whittling or incising a design into the skin while the cane is still green. It is then rubbed with colour–black used to be standard, red has become very popular, too–and vigorously polished with a cloth. The colour will come off the smooth bamboo skin but remain on the areas exposed by the knife, so the design stands out in beautiful negative.

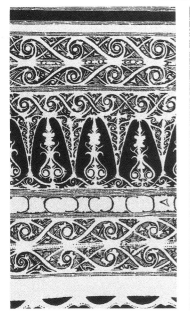

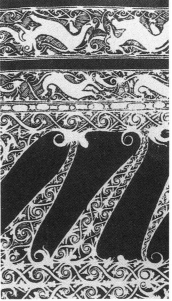

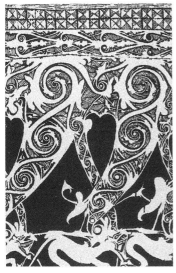

7. Bamboo designs used by the Kenyah (Bahau) of the upper Mahakam in the 1880s, from A. W. Nieuwenhuis, *Quer Durch Borneo*, Vol. 11, 1907.

Bamboo whittling designs usually feature curves, lines, tendrils, and hooks according to the maker's tribal style and fashion (Plate 7). It is folk-art in that anybody may try his hand at it; no special ritual induction is needed. It is often a young boy's first attempt at handicraft as there is no taboo involved in quietly getting rid of a botched piece!

Sword Sheaths

Basically, a sword or *parang* sheath (Plate 8) consists of two boards of wood. A space to accommodate the blade is hollowed out, then the boards are lashed together with strong creeper fibre or, less commonly, with brass wire.

The cavity is shaped to fit the sword. Even in haste, the user holds the sheath across its back only and withdraws the blade with care to prevent injury to the fingers. This scabbard is worn at the belt attached by a rattan loop.

Common and farm *parang* sheaths and handles get little decoration beyond a smoothing of the wood and moderately fancy lashing. War and ceremonial *parang*, on the other hand, have

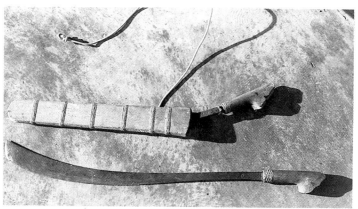

8. Recently made *parang* and sheath.

many hours of skilled work devoted to their adornment (Colour Plate 7).

Strong, resilient wood that will take on a good polish is chosen. The motifs for a knife sheath, especially for a war *parang*, have to be carefully selected. Human masks or leopard faces with prominent fangs and bulging eyes are common.

The lashing to hold the two boards together is artistically plaited of the finest fibre or brass wire for a good *parang*, and these bands hold decorative tufts of hair. Enemy hair in the past, goat hair nowadays, is neatly bound and sometimes lightly dyed. Beads can be attached to the lashing or, in some instances, outer covers for a whole scabbard are made entirely of beadwork. Metal studs and inlay embellish some sword sheaths.

No Orang Ulu *parang* is complete without the small working knife kept in an outer pocket of the elaborately decorated sheath. This little knife has a slightly curved blade 10–15 cm long and a handle up to 30 cm long. It is used for every purpose from nail-trimming to woodcarving; after years of use the blade may be worn thin from constant whetting. As it is part of a 'set' with a *parang*, its handle is embellished to match.

A bone-hilted *parang* usually has a bone-handled working knife. Its haft is, at the most, incised or carved in very flat bas-relief as knobbly decoration would impede the workman's grip on the tool. The terminal knob may feature an animal or human face.

Besides the small knife, the traditional Borneo carver had very few tools at his command. For rough preliminary shaping he used a long triangular-shaped iron head which could be lashed to a handle in two ways: with the cutting blade at right angles to the stem, making an adze, or with the cutting blade parallel to the stem, making an axe. Until the arrival of imported axes and, more recently, chain-saws, trees for building, boat-making, land-clearing, carving, or any other purpose were felled with this tool and the *parang*. The modern carver, however, does not

despise the use of chisels, gouges, drills, and fret-saws to facilitate his task.

Sword Hilts and Bone Carving

Sword hilts are often carved of good hardwood. Any man who is competent to make a *parang* sheath may carve a wooden handle; he needs no special skill nor ancestral permission to do so. More rarely, sword handles are made of brass, but these usually originate from Brunei and are probably copied or taken from an old *kris*. High-quality hilts for Kayan and Kenyah *parang* are made of a section of deer antlers.

A common motif for a sword hilt is a human figure or face, stylized and adapted almost beyond recognition. One common feature are the bulging eyes, usually placed above the antler's natural division. Some beautiful old Kayan swords have a crouched dwarf figure embracing the whole hilt, with its face towards the weapon's owner if it is stretched out and with a derisive pair of buttocks turned towards the enemy.

Deer horn, deer bone, and another very precious material, hornbill ivory, are worked with the small all-purpose knife attached to the *parang*. The workman has a whetstone at hand as his tool needs frequent sharpening. He may use awls and, more recently, files to mark out the design, but the main work is done with a simple 10-cm blade, expertly handled.

The horn carver was traditionally a man apart, rather like the swordsmith. He had to make sacrifices to the spirits and dedicate his work to a chosen supernatural helper. Buying a sword hilt, or commissioning one to be made, used to entail a fee for the carver and another, separate fee for his guardian spirit.

Deer horn and bone were used for other purposes, too, notably the manufacture of hairpins. These were worn by Kelabit men to keep their hair in a loosely wound chignon since a floating mane might have been a hindrance or even dangerous

while they were working or travelling. The end of such an arte-
fact was decorated with carvings; the shaft was merely incised.

Bottle stoppers were also carved out of deer horn and some-
times wood, the lower socket being smooth and polished, the
rest fancifully decorated with dragon-dog heads, scrolls, or
branches. The more common alcoholic drink, rice beer, was
usually brewed in and served from jars, but distilled rice spirit
was kept in bottles and was considered worthy of the most intri-
cate stopper the artist could produce.

Deer horn and bone are commonly called 'ivory', but Borneo
has long been known as a source of 'yellow ivory' (*ho ting*), the
material the Chinese Emperor's belt buckle used to be made out
of–hornbill casque. Rarer than elephant ivory, it fetched much
higher prices, and its use in China was restricted to the Court.

Hornbill ivory is a slightly translucent substance, with yellow
shading into red (from the Royal Hornbill). In order to preserve

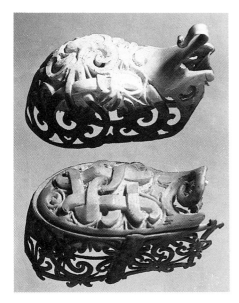

9. Hornbill ivory ear-
pendants (Photograph
Sarawak Museum).

this texture, the hunter who has shot the majestic bird has to cut out its preening gland and rub the beak with it. Dry ivory, such as that obtained from a bird not immediately retrieved but found dead in the jungle days after the shooting, is completely opaque and eventually streaks white. It is also more brittle to work.

Sarawak's Orang Ulu have traditionally fashioned hornbill ivory into fine ear-pendants (Plate 9) and other articles of personal adornment. The material is marginally softer than deer antler and faintly waxy, and can be carved into very fine, lacy scrolls.

All species of hornbill are protected under Malaysian law and the sale of hornbill casques or new hornbill ivory artefacts is illegal.

Woodcarving for Domestic Use

Many household utensils in Sarawak are made of wood and in the past, when leisure and inclination were not lacking, were always beautifully carved.

Not only sword handles, but even the handles of kitchen knives, matting awls, spoons, rice serving scoops, and ladles were decorated. Bottle stoppers, container lids, vessels, troughs, low seats, lamp stands, netting shuttles, plates, and serving platters were all made of wood and usually carved (Colour Plate 8).

Tools for the domestic manufacture of cloth and mats could be embellished. They made the ideal courtship present: a young man carving an elaborate awl haft for the lady of his heart was expressing a secret wish to share a fine mat with her. One who carefully carved a fancy fibre-rolling board for his best girl hoped she would make him an elegant piece of beadwork in return, and an Iban bachelor who presented his betrothed with a shuttle and a beater was hinting that she should soon complete her first *pua kumbu* and thus qualify for matrimony!

The Kenyah guitar, the *sape* (Colour Plate 9), is a piece of woodcarving. The workman selects a bole of soft white wood with a distinctive smell which repels insects. He trims the piece to a length of about 1.2 m, splits it, and roughly shapes each half into a neck and body with his *parang*. The body is hollowed out with the same tools used for ship-building—the iron head that may be positioned as an axe or adze, the *parang* and, finally, the small knife for smoothing and trimming. Chisels and gouges are a modern improvement; fire is seldom used.

The carver is usually a musician as well. He places the pegs and strings his instrument and sets the frets with a wax or gum so they may be moved as the mode of his melody demands. He carves or, more commonly, paints decoration on the instrument's flat top—all but the most shallow surface relief carving would interfere with the board's resonance.

Young men used to carve paddles for the girls, or for their own use. Longhouses were always near watercourses since the river was the easiest and most common means of communication. Some people might not know how to swim, but they could all paddle.

The big longboats belonged to rich aristocrats or to the community whereas smaller dugouts were owned by a family or an individual, but everybody had his or her own paddle; even now permission must be sought before one can be borrowed. It is perfectly in order to use a plain paddle, but a fancy one is cherished as a memento of its manufacturer and as an item for display. At modern river regattas, each team uses uniform paddles though they are more usually painted to match the boat rather than carved.

Longboats, particularly war-boats, were elaborately carved in the past. The Orang Ulu produced veritable masterpieces, nearly always shaped as the head of a dragon, dragon-dog, or crocodile ready to 'bite' the enemy craft (Plate 10). Sea-going longboats which were equipped with open-sided cabins and

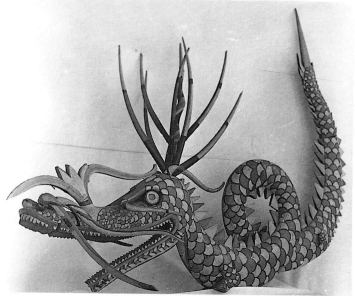

10. Painted dragon from ulu Belaga. The dental decoration points to a crocodile model (Photograph Sarawak Museum).

cooking platforms, much used by the Iban in the nineteenth century, had the fascia boards of their awnings carved as well as the supporting posts, the gunwales, and the prows.

2

Metalwork

The travellers reach a valley with charcoal pieces
The place where warriors' swords are tempered
By Selampetoh
Behold him who forges expertly, Selampeta
Him who shapes men deftly, Selampandai!
Diligent women he tempers in a trough of heart-wood
So they will be able to weave beautiful baskets
Brave men he tempers in a trough of iron
So their courage will remain steadfast unto death.

Iban festival chant[1]

How Sarawak's natives learnt the art of iron production, as distinct from working existing metal, is unknown. The traces of an early iron industry at the Sarawak River mouth have been quoted as a medieval precedent, and meteoric iron has been suggested as the earliest indigenous source of strong metal in Borneo (Hose and McDougall, 1912: 193; St. John, 1862: 113).

Iron is certainly held in awe and respect by all indigenous tribes. Healing, strengthening, and purifying properties are ascribed to it, not only to good blades but, in some contexts, to any scrap of iron, even a nail. The warlike Kayan people distinguish between a war weapon, a utility blade, and an old one which may be worn out, but is still suitable to present as an iron offering or a ritual fee.

Padi fields are blessed with a piece of iron. An iron blade forms part of many propitiatory offerings and fines, to be presented either to the spirits or the injured party.

[1]Sandin, Benedict, *Pengap Gawai Batu*, (*manggai di menoa Selampandai, Selampandai nyepoh kitai mensia*), Borneo Literature Bureau, Kuching, 1968, p. 60.

Some funerary rites demand the inclusion of iron in a coffin; without it the deceased would have difficulty reaching the celestial longhouse in the underworld. After a specified period, the bereaved family 'breaks' mourning by biting on an iron blade. Low-class artisans commissioned to work on the grave monument for an Orang Ulu aristocrat have to be presented with gifts of iron to strengthen their souls.

Iron is passed over the mouth of a bottle to render the water in it fit to be used as medicine. Iron, usually in the form of a nail, and earth have to be deposited under a jar of fementing rice liquor to make sure the contents will not turn sour.

The Bidayuh, competent iron-workers, if not artists, are generally believed to have had the use of metal earlier than other indigenous people. Archaeological investigations in West Sarawak have revealed a stone age much more remotely past than in other parts of the State (Harrison and Jamuh, 1956: 461). Some authorities ascribe this remarkable fact to the birds' nests caves within the tribe's lands, in the catchment of the Sarawak River. The Bidayuh had a highly valued commodity to barter for iron with the foreign traders who frequented the river-mouths. Later, they could have been the workers who smelted the metal around the now silted-up port of Santubong. Evidence of such activity has been found though the scope and purpose of it remains uncertain (Harrisson and O'Connor, 1969; Christie, 1985).

No iron ore has been worked in West Sarawak during the last two centuries although there were gold and antimony mines, producing mostly for export. Sarawak first appeared in Western writing as 'Cerawa, the place antimony comes from', an afterthought in an early Portuguese work on geography (de Barros, 1777).

There are known iron deposits in various parts of Borneo, and those in the knot of highlands near the sources of the main rivers (Mahakam, Kayan, Baram, Rejang, and Kapuas) have

been exploited by the residents until comparatively recent times.

Two much respected authorities on Borneo, Hose and Nieuwenhuis, are, surprisingly, in total disagreement about the quality of indigenous iron, which used to be obtained in the following manner: A quantity of ore was collected, piled into furnace pits layered with the necessary amount of charcoal, and blown to melting heat with the aid of cylinder bellows. As the pit cooled, iron lumps would be left. Hose (1912: 194) describes the product as 'metallic iron and steel...and swords made from it by the Kenyahs are still valued above all others.

Nieuwenhuis, on the other hand (1907, 11: 200), claims that what is eventually found cooling in the pit is 'a lump of iron mingled with slag and charcoal.... [I]f a smith tries to make a steel weapon out of this sort of raw material, it is by coincidence that he succeeds at first try; most swords have to be re-forged, fused and mingled with other metal....' Elsewhere he suggests (11: 197–206) that the traditional process of tempering steel in water was very much a hit-and-miss affair. Both authors, however, agree on the quality of a native-made sword forged from imported metal, with Hose backing the Kenyah as the most competent smiths and Nieuwenhuis the Bahau or Saba'an.

Smiths and Forges

There has never been any doubt about the native swordsmiths' skills. They eagerly bought foreign iron when it was available, recognizing its superior quality; today's material of choice is car springs though good blades may be produced from any scrap iron or steel including a worn-out file!

Most longhouses and rural kampongs have a forge, detached from the main buildings because of the danger of fire. The Kelabit and some of their neighbours do their ironwork during

the *padi* season, under the shelter of farm huts far away from the longhouse.

A surprising number of old-fashioned bellows are still used in which air is forced down two hollow logs by means of feather-padded pistons (Plate 11). The down-stroke of the piston rod stiffens this lining and forces the air down and out through clay tubes into the fire. The feather bunch collapses at the up-stroke and permits fresh air to be sucked in. The pistons are worked patiently by an old man, perched on a frame several feet above ground from where he can give his comments on the work in hand. This use of feather linings is common to the Iban and Bidayuh; the Orang Ulu use tree leopard or wild cat pelt. The stiff hairs serve the same purpose as the feathers: they bristle and expand when pushed down 'against the stroke' but slide smoothly when pulled up.

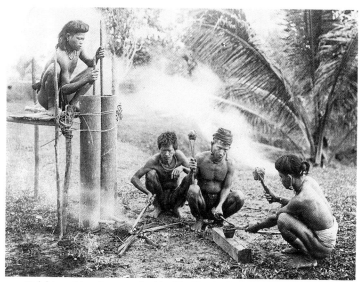

11. Kelabit smiths photographed by Dr Charles Hose in the 1920s (Courtesy of the Trustees of the British Museum).

The anvil used to be a large rock, the hammer a stone lashed to a rattan handle with loop-shaped supports sufficiently elastic to absorb the main shock of each blow. Metal hammers, pincers, chisels, and other tools are commonly used today, and the anvil is usually a long flat iron piece. Shop-bought anvils of the Western kind are used by modern smiths.

New forges are equipped with valve bellows or hand-driven propeller boxes. Any Iban farmer can carry out simple repairs on tools and knives, which is what village forges are used for. Not many men take the trouble of making their own *parang*, the all-purpose utility weapon without which no male and few female Sarawakians of whatever race would go to the jungle. Most are content to buy it in the bazaar.

Good blades are still produced by Sarawak's up-country smiths. Among the Kenyah and the Kayan, the tradition of swordsmithing is stronger, and the specialist craftsman respected and admired.

The Penan are known as excellent smiths in some regions, for instance, Sungai Silat in the upper Baram. Their more commercially minded neighbours used to supply them with iron and commission work in exchange for simple provisions, tobacco, or cloth.

A 'real headhunter sword', a *parang ilang*, is a souvenir for which tourists are prepared to pay good prices—and occasionally cut their fingers when testing the edge. A blade made by a Sarawak swordsmith is *not* a toy! The Borneo blade is not strictly speaking a sword, but a cutlass with a straight or curved back and one cutting edge (Plates 12 and 13). The Kayan even produce right-handed and left-handed weapons to accommodate the user's natural bent.

Among some people of the Baram River system, 'masculine' and 'feminine' *parang* are produced. This distinction has nothing to do with the genital significance of the decoration on fancy blades. The man's blade ends on a diagonal cut, the

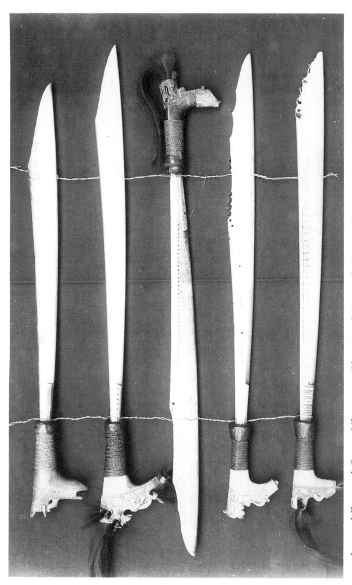

12. Assorted Iban and Orang Ulu *parang* (Photograph Sarawak Museum).

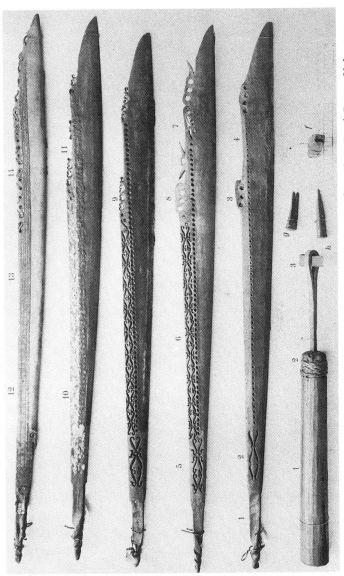

13. Kenyah and Kayan swords, chisels and their holder, from A. W. Nieuwenhuis, *Quer Durch Borneo*, Vol. II, 1907.

woman's is rounded. Men wear their weapon around the waist and carry a little working knife in a scabbard pocket. To go to the farm or the jungle women often carry a *parang* and a small working-knife in their back-baskets. This gender distinction is by no means common to all Sarawak people, though most women prefer using a lighter *parang*.

Quality ware is forged with the most basic tools and apparatus. The smith heats the iron bar, then beats it flat. Depending on the amount of elasticity required in the finished product, he may layer the mass by folding, re-heating, and hammering it several times. He shapes the blade as he goes, not using any pattern but his memory.

When the smith has achieved the right shape, the blade needs to be hardened. For this purpose it is plunged into water while still at a dull red heat. Part of the prestige of blades produced in the *ulu*, the upriver areas, attaches to their hardness, induced according to popular belief by the coldness of the mountain streams in which they are tempered. Further downriver, people say, all water is lukewarm!

The characteristic curly fretwork decorations on a Kenyah sword (see Plate 13) are made by chiselling notches into the back of the hot blade, then forging the resulting tongues longer and bending them with pincers or pliers.

Many ceremonial blades are decorated with brass inlay, usually geometrically arranged patterns of dots. The weapon is punched in the required places, then heated brass wire is passed through each hole and cut off flush with the surface. The whole area is carefully re-heated and hammered to marry the two metals. Incised decorations are chased on cold metal.

The grinding and polishing of the edge is considered a most important job, one carried out only by expert craftsmen. Formerly, sandstone of ever-decreasing coarseness was used, and a hard waxy leaf to give the razor finish. By this method an experienced worker took 10–14 days to set a really first-

class blade. The modern smith sees no obstacle to the use of file, whetstone, and oilstone. The purpose of the exercise, after all, is to produce a blade that will 'eat' anything from a single hair to a man's neck. Although the smith's craft is hedged around with ritual and taboos, improved technology is seldom despised. The Kelabit of the ulu Baram, for instance, have learnt the use of oil for hardening metal.

Smithing is not only a prestigeous occupation, but is also potentially dangerous. Among the Orang Ulu, the smith was considered to be attended by and bonded to special guardian spirits; a novice swordsmith was required to dedicate himself to powerful protectors. Sometimes a sickly youth was apprenticed to the craft by his parents in an attempt to oblige the spirits to safeguard his health. To keep their benevolence he had to give them prescribed offerings from time to time, and keep a few potent old beads and other charms in the smithy and among his tools.

Most Kayan and Kenyah swordsmiths were members of the upper classes. This exalted status placed them closer to the spirit world, and their resources permitted them to make the required sacrifices without stint. Moreover, the Kayan and, to a lesser extent, the Kenyah and Kelabit aristocrats could claim corvée labour from the lower classes and slaves, so a talented smith need not interrupt his task for seasonal farm work. He could cultivate his skills to the full, becoming a true artist whose services were sought far and wide. Ordinary work like mending hoes and weeding sickles could still be done by a yeoman.

The occasional lower-class individual who showed skill and aptitude at the forge was not despised, however. The chief of the longhouse might decide to exempt him from seasonal farm work if he was a really outstanding smith. The main part of such an artisan's output became, of course, the chief's property.

Much care and craft is lavished on the production of fine

blades. An equal amount is devoted to the manufacture of the sword hilt and the scabbard. These are sometimes but not always made by the smith himself. If the hilt is bone or deer-horn it will be carved by a specialist in that medium.

The Bidayuh of West Sarawak, while using the all-purpose *parang* like everybody else, have a traditional blade of their own, the *pendat*. Slightly shorter than a *parang ilang*, it is bent at an obtuse angle about one-fifth along its length from the hilt, widening towards the end. A lighter version of the *pendat* is occasionally made for women.

The shape of the *pendat* gives it a swing beyond what might be expected of its length and weight. Like other *parang* it is used for jungle clearing, lopping small trees, cleaning and gutting the day's bag, splitting coconuts, and slaughtering domestic animals.

In villages where the traditional religion is still honoured, a ritual *pendat* is used by the priest during harvest festival ceremonies. This weapon has to be specially wrought for the purpose, and its manufacture is accompanied by offerings to the forge, the anvil, and the god of blacksmiths. It has certain symbolic markings, the most noticeable being a V-shaped distal incision.

The Sarawak Malays use the *parang* for their everyday work. For warfare in the old days and for formal occasions nowadays, they do occasionally wear a *kris*. There has never been a recognized major *kris* industry in the State, however, although individual smiths have turned out fine weapons of this kind. A Brooke officer who worked in Sarawak in the 1840s concedes that: '... those of them who were industrious ... employed themselves in the manufacture of krises, and the carving and polishing of their beautiful sheaths and handles; in this work they excelled all their subjects' (Low, 1848: 145).

Metal Casting

Brass casting used to be a major industry in Brunei, and the Sultanate's cannon, gongs, and utility products were well known and eagerly sought after. The few stories of gun-casting in Sarawak, out of scrap metal or damaged pieces, usually mention that the work was carried out under the super-vision of an experienced (Brunei) Malay.

Sarawak's Iban used to cast a 'fire piston' out of lead or brass, an ingenious device for striking fire, usually kept in the kitchen. Small versions were worn dangling from the belt by men, or carried by travellers in their back-baskets.

Basically a 'fire piston' is a hollow tube of metal about 12 cm long, used with an exactly fitting wooden plunger. The plunger is slammed down and quickly pulled up again; compression of the air ignites a little wad of dry tinder in the bottom of the cylinder.

Such sets are very rare today but they are mentioned here because they are one example of Dayak metal casting. The implement was cast in a bamboo tube encased in clay or earth for insulation. A polished iron rod, held down in the centre of the mould during the casting, made the bore.

The beautiful heavy ear-pendants worn by some of the people of Central Borneo used to be locally cast in brass, some-times by the longhouse folk themselves, but more usually by the Maloh specialist. A clay mould was fashioned and the article was cast in brass melted down from broken household uten-sils. All ingredients for the correct alloy are not locally avail-able.

The Kelabits occassionally make lead beads for their women-folk's bead caps. Used in the side portions of the modern, small-beaded type of cap, these are long tubular artefacts of dull sheen, produced out of lead slugs preserved by thrifty hunters, or bars sold in the bazaar for soldering. The lead is cast in flat

wafers and rolled up, re-heated and pressed, or filed into the long, tapering shape required.

Those who cannot afford thick round ear-rings of brass may cast them in lead. The molten metal is carefully poured into a bamboo tube; when it is cool and hardened the lead is peeled out and bent to make a large ring or a coil to suit the wearer's taste.

Clay crucibles or old cooking pots and charcoal fires are used for this minor smelting operation.

Maloh Silversmiths

If most Dayak men could turn their hand to rough smithing, the production of brass and silver jewellery was considered skilled work, best left to the recognized experts–the Maloh. Individual Maloh craftsmen moved over large parts of Borneo as itinerant metal-workers, from their homeland in the middle and upper Kapuas, south of Sarawak's major mountain chain. Respected skill ensured their safety even in unquiet times. The Maloh smiths usually settled down in a longhouse for a few months, recasting old ornaments, and mending, selling, or producing new jewellery out of metal their customers had obtained elsewhere.

Many Maloh products are still preserved as heirlooms in Sarawak's longhouses: the Iban women's peculiar corsets made of rattan hoops threaded with innumerable tiny brass or silver rings, ear-rings, bracelets, belts, and neck chains of quite a typical, embossed floral motif linked with plain rings (Plate 14).

The Chinese silver and goldsmiths who began to settle in more remote bazaars as the security of the State improved were not slow to copy such proven bestsellers, in precious metals or brass. Many present-day Sarawak silver ornaments are 'in the Maloh manner' but of local Chinese manufacture; the hand-sized buckle of the wide square-link silver belt is decorated with an embossed Fat Buddha.

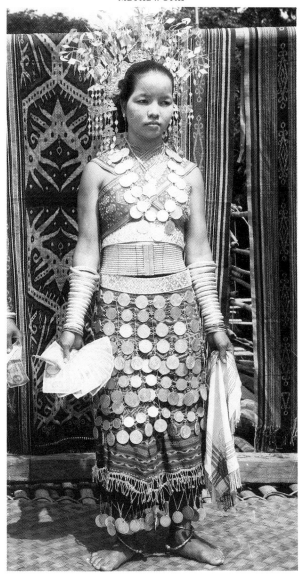

14. An Iban girl wearing silver ornaments crafted by Maloh sil-
versmiths (Photograph Sarawak Museum).

3
Plaiting and Basketry

After splitting the bamboo finely, making the mat begins.
It is begun by joining the pieces together
Into a bunch, like dried grass hanging over a rock
After tying they start to weave
What pattern are you making, young girls?
Patterns like ferns that grow in the flat land
Patterns like flames of burning fire....

<div align="right">Bidayuh women's prayer[1]</div>

MANY jungle creepers and reeds are plaited into mats, baskets, and hats, but the most versatile material is probably *rotan* (rattan), known to commerce as Malacca Cane. *Rotan* belongs to the palm family and is characterized by long, strong, pliable shoots varying in thickness from 15 cm to 0.25 cm or less. It grows best in dense tall jungle, as the head's search for light forces it up towards the tree-tops.

Rotan is usually harvested by men who bring it home cut into convenient lengths. The thorny outer skin is stripped off, exposing the smooth cane which is the mat material of choice, and then the *rotan* is split into 4–6 divisions, depending on the thickness of the rod. For fine work only the smooth skin is used; the shiny side will be outside, the dull inside the finished artefact.

If all pieces have to be exactly the same width, as for fine work, the strips are passed through a calibrator, two knives secured upright in a block of softwood, which shaves away excess material on both sides. *Rotan* preparation is not strictly

[1]Rubenstein, op. cit.

gender-linked work. In some areas the women do it, in some the men may lend a hand. All but the heaviest baskets and mats, however, are made by girls and women.

Rotan rods are used whole if supple strength is required. Shields were woven of *rotan* and heavy-duty carrying baskets are still made of it. If it is needed for lashing or tying, especially where it will get wet (for instance, tying up boats), it is not split.

Mats

Rotan is much used for making mats where strength and dura-bility are required. Usually split strips are woven, but there is one notable exception: the *tikai lampit* (Plate 15).

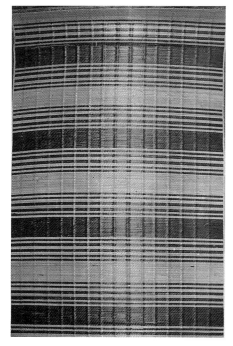

15. *Tikai lampit* (Photo-graph Sarawak Mu-seum).

Tikai lampit can be very large mats, as large as 2.5 m by 6 m. Split *rotan* canes up to 1 cm thick and of uniform length are laid side by side. These are pierced with an awl, using a hardwood stick with a groove and perforations at regular intervals as a gauge, and threaded together. The ends are bruised to expose the creeper's fibre which is plaited into a firm, decorative edge. This mat can be rolled without any danger of breaking the material, though it can never be folded. *Tikai lampit* are commonly made and used by the Kayan, Kenyah, and Kelabit people. They are also a much sought-after item of commerce in the bazaars and towns of Sarawak as they are very attractive and are pleasant to walk on barefoot.

The great majority of Sarawak mats are diagonally woven. The work starts in one corner. From there the weaver makes one edge and then has two sets of strands before her, the 'left-hand' and the 'right-hand' which are woven under and over each other.

The standard mat-weaving pattern is 2:2, that is, each strand covers two and goes under two of its opposite numbers (Plate 16).

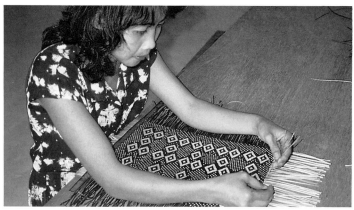

16. Mat-weaving, 2 : 2 pattern.

This is used for edges, or for plain parts. Self-coloured décorations are made by variations in the number covered or passed.

The split *rotan* can be stained before working and colour then becomes part of the pattern. Traditional dyes were indigo, soot, or dark earth to make black strands, 'dragon's blood', a waxy substance obtained by boiling *rotan* seeds, to make red. Modern weavers use oil or emulsion paints to gain a rainbow of colour for their mats and baskets.

Sarawak's Penan are famous for the mats and baskets woven by their womenfolk. They use the finest *rotan*, plaited so closely that some of their mats are said to be watertight. The most typical are two-coloured mats, plain ones in a kind of tartan pattern, or fancy pieces decorated with elaborate designs. These are occasionally available in the bazaars downriver but generally the Penan use them as barter objects for cloth, knives, foodstuffs, and other necessities.

The Penan and other Orang Ulu create asymmetrical, sometimes picturesque designs, including human and animal figures, in their mats (Plate 17). Lively scenes from the hunt or from old legends are represented in some, including diagrams of the underworld and how to get there. The Iban, Bidayuh, and Melanau use a vast number of geometrical patterns in their *rotan* weaving. These may have the names of animals or various plant parts, but they are not realistically represented. The use of lettering, State crests, badges, and patriotic symbols is a recent innovation.

Besides *rotan*, the leaves of wild *pandan* can be employed to make mats. Such pieces are soft but not very durable, and are often not meant to be lasting. The *pandan* strands are folded double to give them extra strength, and since it is a fairly absorbent leaf, *pandan* is often dyed red or green to give a decorative plaid effect to the mats. Sago leaf, with the central spine removed, can also be used to make 'rough' mats for

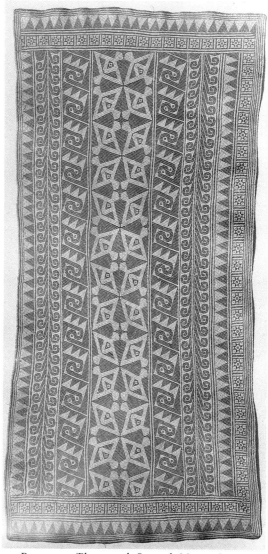

17. Penan mat (Photograph Sarawak Museum).

sleeping on, for sitting on at picnics or in a boat, and even for wrapping things.

Another popular material for mats is a reed, *bemban*. It is softer than *rotan*, stronger than *pandan* or sago leaf, pliable, smooth, and very comfortable to sleep on. *Bemban* may be dyed for decoration, but traditionally the patterns are woven into the fabric and only show up in oblique light, like damasque. Fond enough of using colour otherwise, Iban women have attained considerable expertise at this subtle craft.

Bemban mats have not the strength of *rotan*. They are less used as sitting mats and never for 'meeting mats' when large crowds are expected. The proper mat for that purpose is woven out of strips of tree bark and split *rotan* lengths on an improvised loom, usually by the men. Unlike most others, this kind of mat is worked vertically/horizontally. It is laid down to strengthen the floor if a large gathering is to be held; otherwise it is relegated to rough use, for instance, for drying farm produce, *padi*, pepper, illipenuts, and cocoa beans on.

A mat now falling into disuse is the seat mat that dangles from the back of men's belts (Plate 18). Formerly, it was something dry and clean to sit on if the wearer wanted to take a brief rest wherever he was, usually on the farm or in the jungle. Everyday seat mats were utilitarian objects, made of strong material sometimes lined with animal skin to protect the owner from thorns or sharp stones.

During festive occasions, when everyone sat indoors on fine floor mats and seat mats became redundant, fancy ones were worn as part of the gala costume. They were lavishly decorated with fancy patterns, seed bead embroidery, cloth appliqué, fringes and edgings of boars' tusks, little bells, bead tassels, or feathers—no bar save the dandy's taste and his lady's dexterity—for such a mat was made by young wives, girl-friends, or—lacking these—sisters!

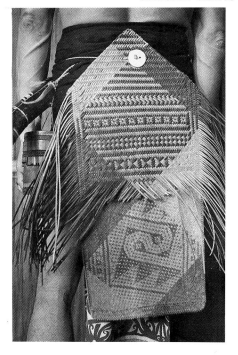

18. Seat mat (Photograph Sarawak Museum).

Baskets

Man—and this particularly includes Woman—has always been the beast of burden in Sarawak. Goods are transported by boat if at all possible, to the extent of pushing, pulling, dragging, and finally carrying the frail craft across Borneo's rugged watersheds. But where no boat can reach, goods have to be moved in baskets.

One item that has to be carried regularly is *padi*—unhusked rice. From the farm to the river, then from the boat to the longhouse, enough rice to sustain the community for a year has to be lugged by wiry, muscular bodies at harvest time. Most big baskets have shoulder and forehead straps to make balancing easier. Each can also be extended by standing a rolled-up

mat upright inside it. This thick tube is filled with the precious grain, doubling the capacity so that the load stands high above the head of the person carrying it.

Each tribe has its own version of a sturdy basket, the four corners being reinforced by struts that protrude to make little feet, and its base supported by crossed rods. The one called *ingan*, made by the Melanau and Bidayuh, may have a snugly fitting lid of skin or bark, making it not only useful for carrying heavy loads but also for the storage of valuables. The Kelabit *buan* is narrower at the base and wider at the top than most other large carrying baskets. It is made to hold up to 1 picul (about 60 kg) of *padi*.

The Iban *selabit* is woven of unsplit *rotan* in a loosely textured honeycomb pattern. The back is worked separately and lashed to the sides with laces. This permits considerable expansion to fit a large load. Huge heirloom jars used to be carried over Borneo's mountain ranges on men's backs, safely strapped into sturdy *selabit* baskets.

Properly loaded a big carrying basket will hold 1 picul of *padi*. Sometimes it is specially designated for grain transport, and has a fitting lid that can be used as a reaping basket.

Somewhere between a basket and a pack is a container fashioned of bark of sago spathe. It has a narrow base but widens out towards the top so the centre of gravity is fairly high. Made with a fitting lid, this is considered waterproof and is often used by men to carry their personal belongings on adventurous journeys. The Sarawak Rangers, part of the Rajah Brooke's police, were issued with basket-shaped packs made of sheet zinc and carried by rifle straps.

Baskets, like most mats, are diagonally worked. The weaver starts in the centre of the base. When this has reached the required size, the weaver turns the corner and works upwards and around, straight up or tapering outward as the style of the basket dictates (Plate 19).

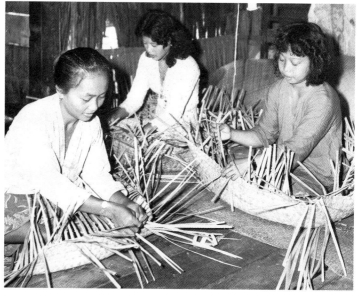

19. Melanau girls making large, rough utility baskets (Photograph Hedda Morrison).

The lip of larger baskets is always reinforced with a split *rotan* rod or other firm material. One kind of Iban seed basket is finished at the top with a sheet of thin wood to which the basket fabric is decoratively 'stitched'.

An exception to the diagonally woven baskets are the Bidayuh *tambok* (Colour Plate 10, Plate 20). These are started on a cross, and after the turning the sides are woven into a standing warp with thinner strands started at the base corner. Some *tambok* have vertical struts worked in, others have one or several plaited or chained reinforced bands of fine creeper fibre around the body. The lip is finished with a rim or plaited work which takes in all the warp ends.

One basket that is well known beyond Sarawak is the elegant *ambong*, a basket for carrying personal belongings on a

44

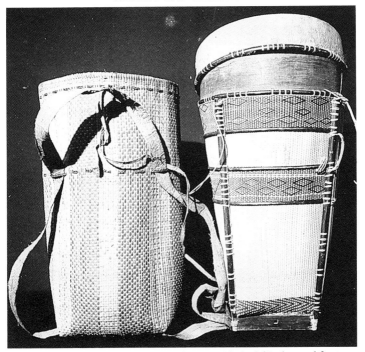

20. Large Bidayuh carrying baskets. The one with the lid is also used for storing personal belongings (Photograph Sarawak Museum).

journey (Plate 21). It is soft and light. One variety is loosely woven but all are very daintily ornamented.

The *ambong* is about 30–45 cm long and 20–25 cm wide. Its base is worked of coiled fibre while the strands for the sides are separately attached around the turning of the base. Its lip is finished with a row of woven loops through which a string is first threaded, then attached to decoratively woven carrier straps. It is not intended to contain heavy goods; the string itself is quite thin and does not pass under the base for lifting strength, though it may be attached at the lower sides for balance.

This basket was originally made by the Penan for their own

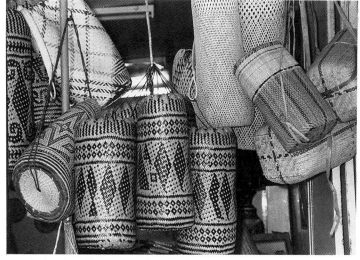

21. *Ambong* hanging up in a shop, with a few *tambok* on the right.

use and as an object of barter trade. However, the other Orang Ulu have taken to producing *ambong*, too, whenever they can get the right material–soft, strong *rotan* that can be split into very fine strands.

There is a wide range of middle-sized baskets used by all tribes for a multitude of purposes, from storing things to covering jars, and for carrying loads smaller than a picul of *padi*, a load of firewood, or a dozen bamboo pipes filled with water.

One essential item of basketry is the winnowing tray, either a flat round basket or a shallow shovel, large enough to toss a family's meal allowance of freshly pounded rice grain to clear it from chaff.

While baskets are used by both sexes, they are almost exclusively made by women. Generally, the smaller the basket, the more fancifully it is worked. A beautiful *sireh* basket is admired by others, rather like an elegant handbag would be

elsewhere—with the difference that the wearer and user in Sarawak has made her own. Painstakingly worked, intricately decorated small baskets are carried by a bride visiting her in-laws after her wedding to show respect to her new relatives, as well as to demonstrate that the young lady they are welcoming into the family is a competent craftswoman and artist.

Social display of this kind, however, pales to insignificance when an authority of real importance has to be placated: rice. Rice, whether as a plant in the field, an unhusked grain, or a ready-milled cereal is given personality status by the people whose very lives depend on it. Spirit offerings inevitably contain rice—cooked, puffed, and raw. The careless dropping of rice grains may give affront to this very touchy deity, and in some regions the 'rice grandmother' is cited to frighten small children into decorous eating habits. When rice has to be stored, it clearly must go into the best containers.

Huge heirloom jars are considered fitting receptacles for polished rice in most communities—or the grain a fitting content for the antique jars. But for the storage, the selection, and the transporting of unhusked or seed grain, bark bins and baskets are more convenient.

Everybody helps with the work of producing rice. The jungle is felled by the men. Clearing the undergrowth is shared by all. Burning-off is done mainly by the men, though the women help. When the fields are ready for planting, the men dibble with long sticks and the women dole out a few precious seeds per hole, a portion of last year's harvest.

A woman, in her capacity as mother and nurturer, is in charge of the vitally important storing, planting, and 'nursing' of the *padi* seed. A special basket is used for planting *padi*, carried by one or two loops at the wearer's waist so she can work unhindered and without danger of spilling the seeds (Plate 22). Such baskets are beautifully worked, and in some areas have a broad wooden or spathe lip. Some seed baskets are

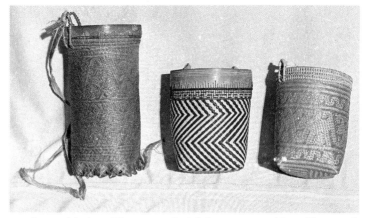

22. Iban seed baskets. The one on the left has a contoured base (Photograph Sarawak Museum).

very closely woven—so the grain will grow thick and dense—and all are decorated with motifs symbolic of growth. An unusual kind of seed basket occasionally seen in Iban areas has a contoured base in the shape of cones, steps, or protruding hemispheres to keep the seed grain happy!

A basket with a contoured base may have another function. Woven in a long cylindrical shape, 8–10 cm in diameter and 13–15 cm long, it may hold offerings during a Gawai, a traditional festival. Sometimes a glass or bamboo container is fitted into the basket, which will then serve as a drinking vessel for ceremonial libations. Rows of these baskets filled with offerings may be hung from a carved beam. At other ceremonies, sacred plants may be stood upright in the baskets, making them serve in effect as flower vases. Such a basket is always suspended or hand-held, as its uneven base does not permit it to stand by itself.

Sarawak basketry that is sold in local shops and overseas is now being made in a variety of shapes and models, primarily purses and handbags with detachable lids and two loop straps

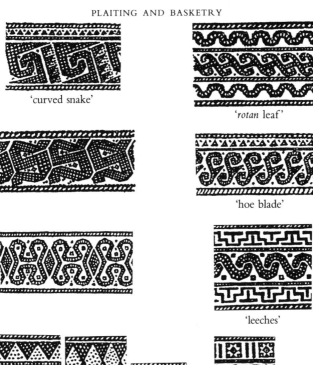

'curved snake'

'*rotan* leaf'

'hoe blade'

'leeches'

'wriggly'

'star'

'bamboo shoots'

'bird's footprints'

'star'

23. Basketry patterns on Kanowit baskets from the Brooke–Low Collection, from Ling Roth, *Catalogue of the Brooke–Low Collection in Borneo*, Sarawak.

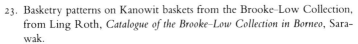

49

(Colour Plate 11). These wares are usually colourful–black and white, often black, red, and white. The dyed strands are used in bands of twelve to twenty, but the baskets are still woven in a traditional flower, shoot, bird, or animal pattern, shot through by broad belts of colour (Plate 23). Sometimes called 'Kanowit baskets' after a tribe on the middle Rejang recorded as making such artefacts in the nineteenth century, the traditional prototypes are sturdily strutted and rimmed and wear well.

Fish Traps

There is one cane artefact that is not a basket, but which is still much used even by town dwellers who have access to a creek or river: the fish trap (Plate 24). All tribes have their own version, from small models that just fit a creek near a river's

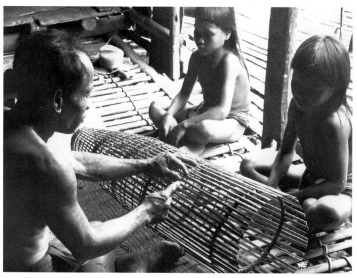

24. Iban man making a fish trap in the 1950s (Photograph Hedda Morrison).

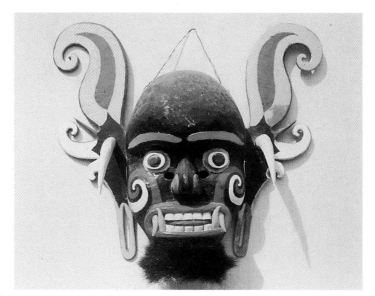

1. Kenyah mask with elaborate ears (Photograph Sarawak Museum).

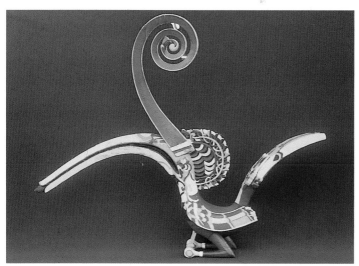

2. Iban hornbill effigy (Photograph Sarawak Museum).

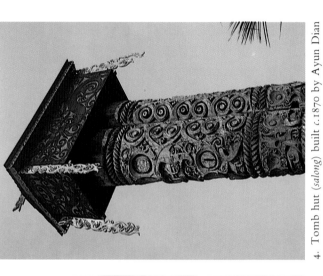

4. Tomb hut (*salong*) built *c*.1870 by Ayun Dian of Ulu Belaga for the remains of his daughter

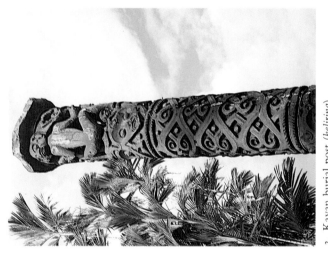

3. Kayan burial post (*keliring*).

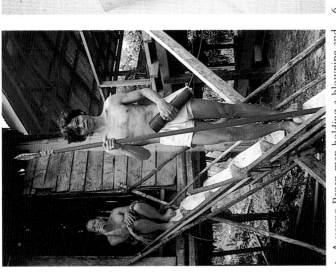

5. A young Penan man holding a blowpipe and dart carrier on the steps of his house (Photograph Sarawak Museum).

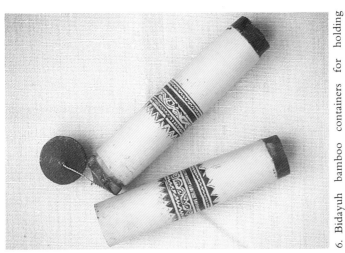

6. Bidayuh bamboo containers for holding smoking utensils.

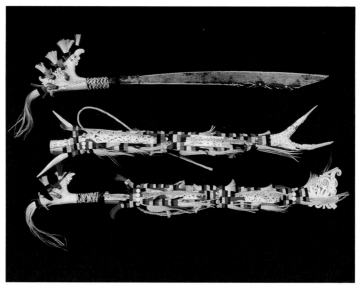

7. Kenyah parade sword (*parang ilang*) with elaborately decorated hilt and sheath (Photograph Sarawak Museum).

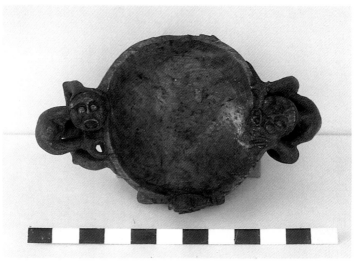

8. Berawan carved wooden food bowl (Photograph Sarawak Museum).

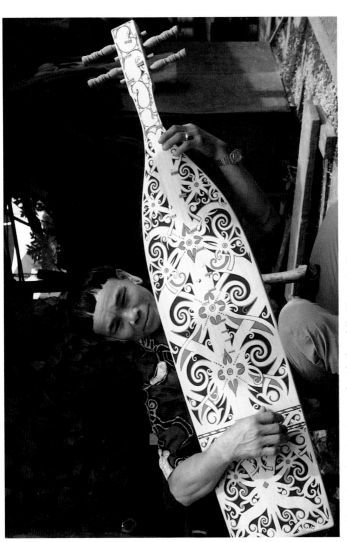

9. Kenyah guitar (*sape*) carved and played by Tusau Padan.

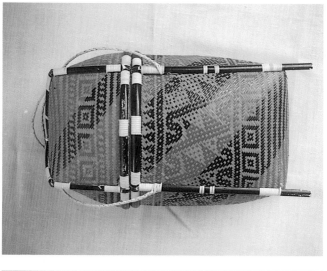

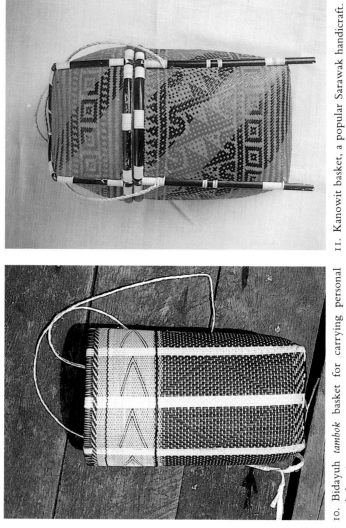

10. Bidayuh *tambok* basket for carrying personal belongings.

11. Kanowit basket, a popular Sarawak handicraft.

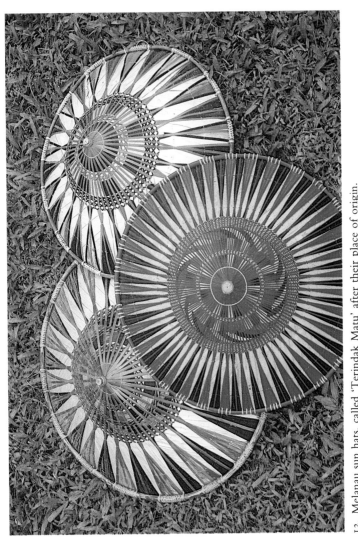

12. Melanau sun hats, called 'Terindak Matu' after their place of origin.

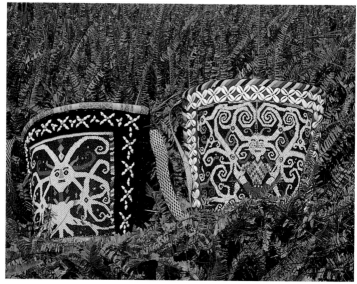

13. Kelabit baby carriers, for upper middle-class and upper-class babies.

14. Beadwork in progress using a paper pattern pinned to a board.

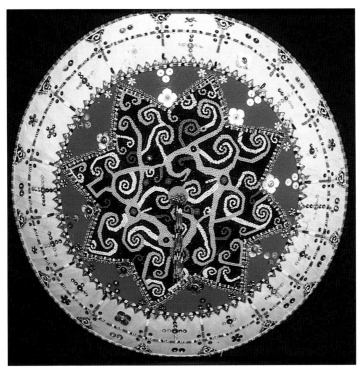

15. Kenyah sun hat decorated with beads.

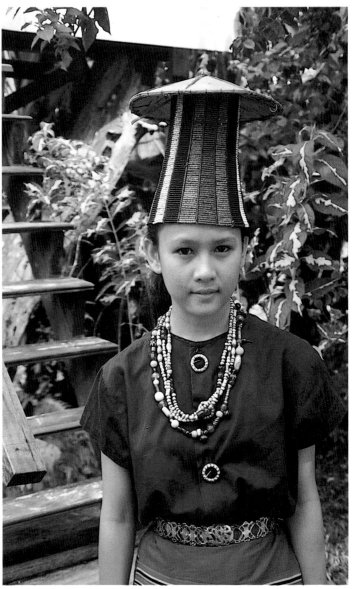
16. Bidayuh girl wearing a tall seed bead hat.

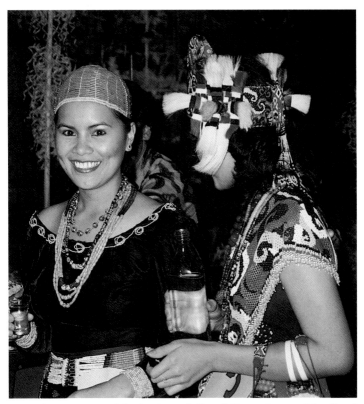

17. Girls wearing a Kelabit bead cap (left) and Kayan decorated headband (right).

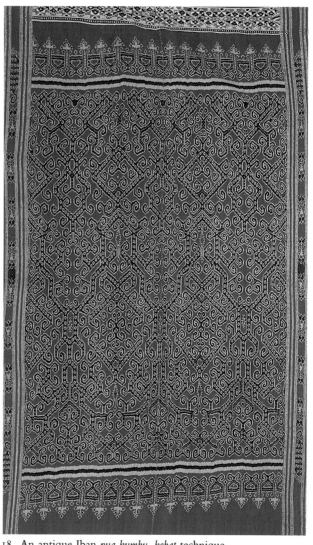

18. An antique Iban *pua kumbu*, *kebat* technique.

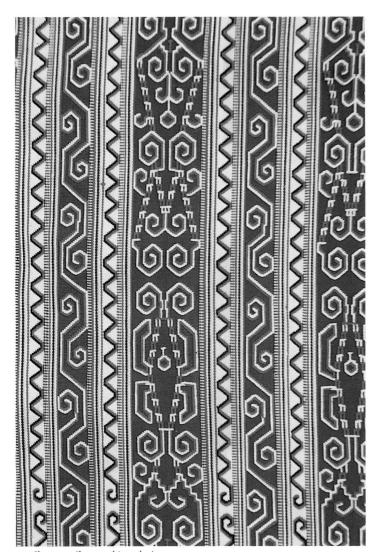

19. Iban textile, *sungkit* technique.

20. *Kain songket*, Malay brocade cloth.

21. Detail of the 'Tree of Life', a Kenyah wall painting decorating the family rooms of a high-ranking chief.

22. Kenyah *aso* table. The supports and the plate are carved from a single piece of hardwood (Photograph Sarawak Museum).

headwaters to the man-sized traps built by the coastal and estuary-dwelling peoples.

Basically, the fish trap is a long cylindrical basket with a hinged gate at one end and a narrow, tapering opening at the other. This mouth is surrounded by inward-pointing canes with sharpened ends; a fish can ease its long slippery body *in*, but is unlikely to find its way *out*. As fish traps are usually set after dark, it is mostly the men and big boys who handle them. Women of most tribes go fishing with catch nets. These may be very loosely woven *rotan* scoops or bamboo baskets.

Among the Melanau, the fish trap has one non-functional use in funerary rites. At a ceremony farewelling the deceased's spirit, some time after the funeral, a fish trap has to be danced with all night until it disintegrates. As it has to be a *stolen* object, owners of a dilapidated trap may conveniently leave it lying outside the house if they know their neighbours are in ritual need of one.

Hats

Nobody in Sarawak shares the Western mania for sun-tans. Borneo people, except for the Penan who do not leave the dense shade of the deep jungle, protect themselves from the sun by wearing wide, shady hats.

The simplest sun hat is made of leaves assembled with their stems towards the centre. Hastily stitched shades or rain shelters of this kind can be put together in ten minutes. But few people are caught by the elements unawares; a normal day in the equatorial rainfall belt is either hot enough or wet enough for everyone to need some cover.

One hat that is popular among the Melanau, but which is known all over Sarawak, is made of broad, overlapping *nipah* leaves stitched into a shallow cone (Colour Plate 12). The bottom layer is of natural-coloured leaf while overlayers are

made of colourfully painted leaves, cut out to produce decorative designs. The top of the cone is strengthened with weaving or stitching and is also coloured. The rim is a hoop of *rotan* halved and then lashed to both the inside and outside edge of the hat.

The Orang Ulu make a leaf hat which is flatter than the Melanau version and which bends downwards around the rim. Because it has no peak, the level top is a suitable place for elaborate decorations of bead and other embroidery. The outer edge is often embellished and strengthened with a patchwork of cloth. This is particularly common on Kenyah hats from Indonesian Borneo where patches of *batik* are used for this purpose.

A type of hat commonly produced by Iban women is woven out of split bamboo or *rotan* in the basket pattern and embellished with fine weaving in two or three colours (Plate 25). Geometry dictates that the area of a cone worked by a diagonal technique is divided into three main sections, meeting at the top. The chosen motif–fish, bird or plant–appears three times, usually separated by bands of waves, rhombs, zig-zags, keys, or other common edging patterns.

Shelter hats are huge, often 1 m wide. They are put on over a plaited inset, attached to the hat or worn separately, which lifts them up. Worn straight on the head some of them would slope right down to the wearer's shoulders, obstructing his view.

The inset or a roughly draped cloth turban effectively lifts a big hat up, allowing air circulation and free vision. The smaller Melanau hats can be worn direct, though a cloth or towel is often thrown over or wound loosely around the head before the hat goes on.

A conical hat has a pointed inset to fit into the underside of its centre. A farmer or fisherman has one made to measure so the hat will not slide about loosely or pinch his temples. Some-

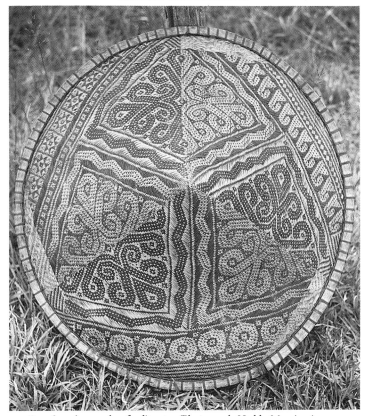

25. Iban farm hat made of split *rotan* (Photograph Hedda Morrison).

times the insets are beautifully woven of coloured strands of *rotan* and decorated with seed bead embroidery or cloth appliqué. This is truly Art for Art's sake, as it is hardly seen under the huge sun hat!

In a farmhouse, it is common to see several big hats hanging on the wall for use by anybody who has to go outside. If each person has his own detached inset, he can tilt on any hat over the top of this, and it will fit. These big shady hats are for daily

use, for people who need both their hands free but who still like the umbrella effect of a big shelter.

Other hats are for beauty. Kenyah and Kayan women generally wear some kind of headband, partly to keep their hair tidy since, unlike other Sarawak groups, they do not traditionally coil it (Plate 26). But a beautifully made headband does more than that! Plain bands of finely split *rotan* are woven in pretty patterns, the ends curled up into a little plume that is worn on one side. Wider bands have a fringe all around. Kenyah ladies wear a woven headband that amounts almost to a hat, open at the top but without a protruding brim.

Now falling into disuse is a headband composed of many short lengths of fibre left dangling at regular intervals, giving a furry effect.

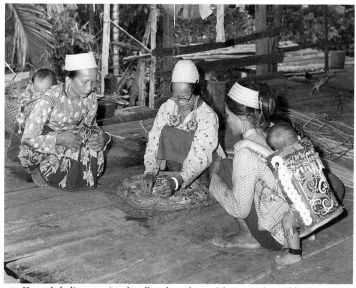

26. Kenyah ladies wearing headbands and cap (Photograph Hedda Morrison).

A recent innovation is the gala headband worn by young ladies who perform in cultural shows. Woven of fine *rotan* or bamboo, it is about 5 cm wide and decorated with beads, tinsel, gold fringe, tufts of goat hair, edgings of brightly coloured satin, or anything else available. (See Colour Plate 17.)

The really well-dressed *ulu* lady wears beads on her head, but of that more in the next chapter.

Men's decorative hats are generally larger and, as they are often worn with feathers, more conspicuous. Many Orang Ulu now use the domed, rimless Kayan hat with a quarter-brim fore and aft, and a row or two of fringe around the hole at the top. This is usually trimmed with hornbill feathers sticking up at the back—a bunch for an aristocrat, one or two for a member of the working classes. Skilled female fingers may add bead embroidery, cloth patchwork, or edgings.

In the upper reaches of the Rejang River, where Iban and Kayan have been living side by side and absorbing each other's culture, a very beautifully decorated man's hat is made for festive wear. It resembles a woven *rotan* helmet, with a front blaze of bead embroidery, surmounted by tufts of hair wound with dyed yarn casings and feathers, all that is magnificient and impressive. Young ladies sometimes wear this hat for dancing or for welcoming important visitors.

A plainer Iban hat is a many-tiered crown simply named 'knobbly basket', a fine piece of intricate *rotan* weaving with all peaks equally spaced and level. For a Gawai this hat is studded with argus pheasant feathers, adding 60 cm or more to the wearer's stature.

4

Beadwork

Let us have a good life by virtue of this string of beads
These beads of bone, these beads of stone
These are the beads of life
Give padi in plenty for our children and grandchildren
Go beads, and tell Bungan Malan Paselong Luan
That we are ready to enter our house!

Kenyah housewarming prayer[1]

ARCHAEOLOGICAL excavations have indicated that beads were one of the earliest items of commerce to be brought into Sarawak from other parts of the world. There are some written references to 'Egyptian, Roman, Coptic' beads from Borneo, though scientific glass analysis disproves such assertions.

Since the interior of Borneo is crisscrossed by trade routes from river to river, beads, being mobile objects, are found in every part of the island. Most indigenous tribes traditionally used beads and still wear them, though not all prize them equally.

The Kenyah, Kayan, Kelabit, Lun Bawang, Melanau, and Bidayuh may be considered the *connoisseurs*. An old Kelabit, Kayan, or Kenyah lady can distinguish many different types of value beads.

Foreign traders were not slow to cash in on this local predilection. An early nineteenth-century guide for mariners and country traders, printed in Singapore, includes a directory of the East Indian ports where money was needed for trade, and

[1]Tama Ino Bulan (Tr. A. D. Galvin), 'Prayers for the Erection of a New House', *Sarawak Museum Journal*, Vol. 22, No. 43.

those where 'beads, baubles and coloured cotton stuffs' would be enough (Earl, 1850). Enterprising travellers ordered replicas of the known favourites. The spindle-shaped facetted carnelian known throughout the region was copiously reproduced in glass by Austrian and Bohemian manufacturers. Although these fakes may have been accepted at face value elsewhere, no Sarawak native was deceived, though the bead got into the local currency as 'small change'.

Unlike most other indigenous tribes, the Iban esteemed silver above other personal ornaments, though those living near the Kayans of the upper Rejang absorbed some of their neighbours' interest, especially when beads became abundant in late Victorian times. The Malays have never worn beads, much preferring gold and precious stones for personal adornment.

Seed Beads

Beadwork as a craft is done almost exclusively with seed beads. These monochrome opaque glass beads vary in size from a mustard seed to a peppercorn, and are available in a multitude of colours. Over the last two centuries, seed beads have originated mostly from Italy, Bohemia, and England; Japan has recently joined the ranks of bead exporters.

The earliest available colours would appear to have been red, white, yellow, and black, the hues of the majestic hornbill's huge and clumsy beak, and of many old beadwork artefacts. Whether this reflected the craftswomen's preference or the availability of the materials, it is not possible to say.

Given sufficient beads and the time to work them, there is nothing Sarawak's Orang Ulu ladies cannot decorate with beads. Hat tops, hat blazes, and headbands have already been mentioned, but jackets and skirts are lavishly decorated with beadwork, too, as are seat mats and the ends of loin cloths. Arm-

bands, necklaces, ear-hangings, and belts may be embellished with beads or entirely composed of them.

The Iban use seed beads to fashion the wide bead collars that complete the female festive costume in some regions. This usage originates from an older fashion of wearing facetted carnelian beads ranged on strings of increasing length. Eight or ten rows of these heavy beads over a young lady's neck and shoulders give the effect of a collar or circular yoke.

Beadwork is not necessarily worn as clothing. A respectable Kelabit baby carrier (Colour Plate 13, Plate 27) is covered in beadwork, as are baskets (Plate 28) from the smallest to the largest. Sword hilt decorations from all parts of Sarawak may also incorporate seed beads, and there are walking-stick sheaths made entirely of beadwork.

There are three common methods of using seed beads for flat decoration: (a) embroidering them on to a background of cloth (Plate 29); (b) working them from a string with one con-

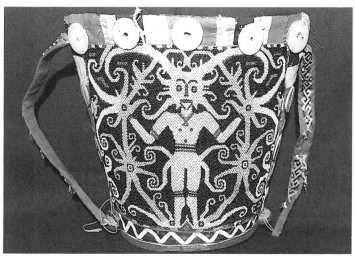

27. Kenyah baby carrier (Photograph Sarawak Museum).

58

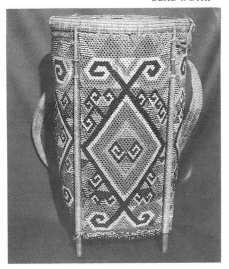

28. Kelabit basket decorated with solid beadwork (Photograph Sarawak Museum).

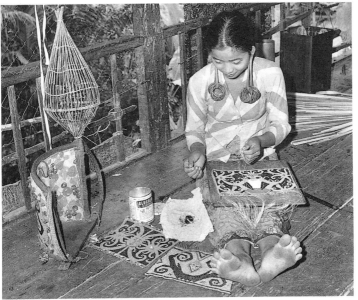

29. Kenyah woman doing beadwork (Photograph Hedda Morrison).

tinuous thread running to and fro, and (c) ranging them on separate, intertwining thread lengths.

The first method is the strongest and the safest should the thread break, although it was not practicable in the interior of Sarawak before thin, strong needles and matching thread were available.

The thread traditionally used for beadwork is obtained from creepers or pineapple fibre. It is stiff enough to permit the threading of beads without a needle but is not strong enough to pierce cloth. If a needle were used and the thread thus doubled, it would not pass through most seed beads.

Method (b) is occasionally used to make very narrow edges to a fabric of cloth or basketry, but for a project of any appreciable size, method (c) is the safest. A large bead-covered basket, for instance, requires up to a square metre of seed beadwork!

Beads are worked on a rectangular piece of board on which the pattern has been incised or, more recently, over a paper template pinned on a board (Colour Plate 14). Traditionally, the patterns were designed and carved by men; women carried out the painstaking and slow process of threading the beads.

A stout string is stretched across the top of the working board. Parallel with it is a string of beads destined to be the edge. The warp threads are attached to this string with half-hitches, between regular numbers of beads. The fabric is now worked downwards by putting beads on the vertical threads, and crossing them at intervals by feeding two strands through one bead (Plate 30). The pattern is produced by colour selection.

Not all beadwork is rectangular. Round pieces–the very elaborate hat-tops, for instance–are started with a ring at the centre, with extra threads hitched on as the circle grows (Colour Plate 15, Plate 31). Some types of beadwork are of tubular shape, for instance the covers of round objects like bamboo *sireh* boxes, walking-sticks, sword sheaths, and the modern

1

3

2

4

30. Common method of doing Sarawak beadwork (By kind permission of Mrs Susi Dunsmore).

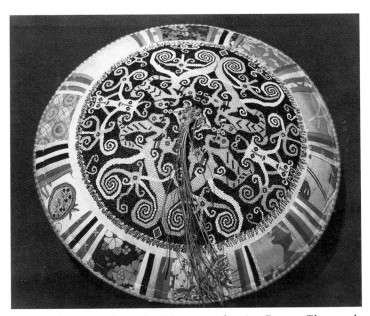

31. Kenyah sun hat from ulu Belaga or Indonesian Borneo (Photograph Sarawak Museum).

61

necklace with a bead 'bobble' at the front. These are all worked cylindrically around a solid centre which is eventually removed. Some old Iban bead necklaces have been preserved which consist of a piece of stout rope covered in beadwork and linked at the front with a larger bead used as a button.

The bead coil or bobble is still made as the centrepiece of a necklace, either of seed or antique beads. Traditionally it consists of very tiny red and black seed beads threaded in lengths of about 8 cm and looped over a piece of wood as a gauge. Some 30–60 loops are required to make a sufficiently dense bobble.

Bead Hats

Beside the seed bead headband, which in the Tinjar River area can be several centimetres wide and look like a tapering hat, there are two distinctive types of bead hats worn in Sarawak. One is a truncated cone made of vertical bands of red, yellow, and black beads on a framework of fine *rotan*, worn by Bidayuh women of the Bukar–Sadong region of West Sarawak (Colour Plate 16). It can add as much as 20 cm to its diminutive wearer's height. Depending on her status in the women's cult, she might add a flat leaf hat to the top, or leave it open.

Some Bidayuh make hats of the same shape of split *rotan*; these are of more recent manufacture. It is doubtful whether any family still has the authentic materials to make a bead hat. The Bidayuh live nearest to the State's capital; if long ago they were handy to the supply routes, they have also been within easy reach of souvenir hunters and antique traders for the last hundred years.

The second main type of Sarawak bead hat is made of much larger opaque glass and semi-precious stone beads. There are two versions of it, both found in the east of the State: the Lun Bawang (Murut) lady's model, which may be regarded either

as a very wide fitted headband or a hat with a large hole at the top, and the Kelabit lady's hemispherical cap (Colour Plate 17).

Basically, these hats help to control the wearer's hair. She pats the black cascade into a swathe, wraps it around her hand a few times and holds it flat against the back of the head while tilting the bead hat over the top. The hair will stay confined unless she engages in very strenuous activity. The hair can also be pulled up outside the hat and tucked in through the central hole, as fashion dictates.

Although each bead-using tribe has its own preferences there are distinct styles that change periodically. For instance, a Kelabit bead cap featuring heavy 2 cm-long facetted carnelians in the front panel, thick shell cylinders at the sides, and cherry-sized brown, turquoise, and yellow beads in the less important back portions is now considered old-fashioned, though it is known to be valuable and accordingly treasured. The current fashion demands fine orange-brown tubular beads over the forehead, home-made lead beads at the sides, and newly bought or semi-antique small blue or other coloured beads across the back (Plate 32). For necklaces, the *dernier cri* in the Kelabit highlands are Venetian lamp beads, replacing an older preference for translucent monochromes.

The Murut bead cap generally has heavy yellow beads in front, followed by brown and turquoise, interspersed with bands of polychrome Murano beads;[2] blue-black with white spots is a favourite. This cap or band has a wide opening at the crown.

Both Kelabit and Lun Bawang bead hats are fashioned of horizontal rounds which fit the head of the manufacturer or wearer. The rounds decrease in size to accommodate the skull's shape, and are vertically linked at the back by string ladders.

[2]Murano is an island south of Venice, where all the city's glassworks were sited in the thirteenth century by an order of the Senate.

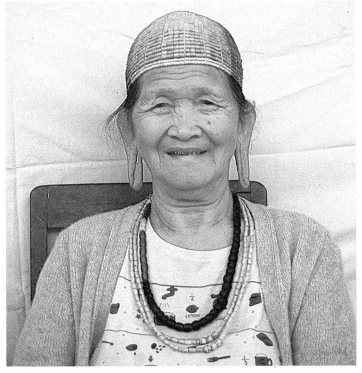

32. Elderly Kelabit lady wearing a valuable bead cap.

The vertical bands of colour that make up the pattern are achieved by carefully co-ordinating each round.

A now-vanishing fashion among Kayan ladies is a tall, slightly tapering bead hat worked in the standard fashion, mounted on a framework of rattan and padded with bark cloth.

All these bead hats are worn to show the owner's status and wealth. Although a simple plaited headband can hold a woman's hair in place as effectively as a bead hat, a lady of the upper class would not be seen in public with rattan headgear!

5
Weaving

When they heard my work was completed so soon, my
 darling,
All the women of the longhouse gathered
Saying how very fine was the design I had woven
With green-blue thread, saying that I, beloved,
Was clever to the tips of my fingers
And they asked how I had progressed to difficult patterns so
 quickly....

Iban love song[1]

Iban Weaving

UNTIL fairly recent times, every Iban woman was a weaver.
Even where imported cotton cloth was available, it was rel-
egated to common use. Bark cloth was used for rough pur-
poses, or for making special articles like belts and carriers.
Good clothing had to be woven on the backstrap loom.

Women's short skirts and sashes were home-made, as were
men's loin cloths, and jackets for both sexes. Small children
usually went naked though girls might have a shell or silver
'fig leaf' suspended from a hip string. As there was no need to
weave easily washable stuff for the little ones, a woman could
devote her time to the most elaborate work of all, the produc-
tion of *pua kumbu*–exhibition lengths of cloth up to 2 m by
1.5 m in size, needed to decorate the walls of family rooms
during festivals (Colour Plate 18).

The most characteristic Iban textile technique is *ngebat*, lit-

[1]Rubenstein, op. cit.

erally 'tie-dye', known as *ikat* in the wider Indonesian context. *Kebat* weaving is considered the crown of a woman's achievement, though she would be expected to know other forms of textile production too.

Edges or prominent parts of garments may be decorated with ordinary embroidery or needle weaving. Minutely detailed patterns can be made by the *sungkit* process (not to be confused with Malay *songket*), the in-weaving of multi-coloured threads to form the decoration (Colour Plate 19). In this technique, the worker twines these strands into position one by one after each shot of the shuttle, using her hairpin or a porcupine quill. A really elaborate piece of *sungkit* may only progress a few centimetres a day. Some Iban weavers are also borrowing the Malay brocade method, though they call it *anyam*, the same term used generally for basketry. As their loom does not have pedal heddles, they use rods to lift the warp threads in the proper sequence.

Kebat weaving, however, needs the most skill and carries the greatest prestige. In the past, a woman took pride in finishing a *pua kumbu* with the best of her craft and cunning. Her standing in the community, indeed her worth as a woman, was judged by her performance at the loom. 'Women's head hunting' they used to call it, a name not thoughtlessly bestowed. Head trophies suspended from the rafters testified to the menfolk's daring and luck. Walls tapestried with beautiful textiles proclaimed the fame of a dexterous housewife and a successful farmer; she would have no time to sit at the loom if her granary was not full to overflowing!

Famous warriors of old were given Praise Names for their exploits. Women could receive the same honour from their peers. 'She Who Knows to Measure [the dyestuffs]', 'She Who Knows to Tie Patterns out of her Own Mind' is how a craftswoman might be dubbed, in elegant rhyme. Such a matron was called upon by others to help them prepare dyes. She pre-

sided over the offerings presented to female deities and was paid special fees. In some communities she was treated like a war leader, as indeed she was of the Women's War Party, and was privileged to get one hand tattooed in token of her skill and competence.

No women were allowed near the men's martial preparations; conversely, no men might see the women at their secret work. In some areas the ladies waited until their menfolk had gone hunting if dye baths were to be prepared; in others they moved to temporary outbuildings on the jungle fringe to do their task. *Kebat* weaving was, and still is, regarded as women's business, a mystery the men are kept out of with a certain amount of good-humoured parade.

Every particle of a *pua kumbu* comes from the jungle. The raw material out of which these masterpieces are made—wild cotton—is a fairly large bush, commonly found in clearings around older longhouses. Its seed capsules burst open to reveal the fibre, which is somewhat shorter than cultivated cotton. The wild cotton is picked, beaten, and carded, then cut into wads and spun by hand—very time-consuming work. A few old weavers still know how to process their own yarn, but they practically never do it nowadays (Plate 33).

Commercial cotton thread may be bought plain or coloured in most up-country bazaars. For *kebat* work only white is used, though weavers in some regions embellish both edges of their *pua kumbu* with red, green, and yellow stripes according to the degree of seniority they have attained.

The colours used for *pua kumbu* are the shades of the jungle—rich deep tones of red and brown ochre, black, indigo blue, and unbleached white where the natural thread was tied and left unstained. Leaves and grasses, earth, bark, lime, and fruit are some of the ingredients soaked and pounded and cooked together to yield just the right shade for each colour.

Kebat is dyed on the warp, a procedure which is more labori-

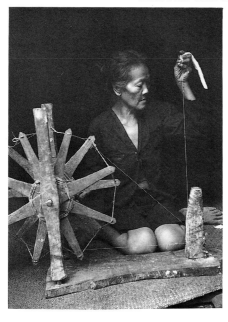

33. Iban woman spinning in the 1950s (Photograph Hedda Morrison).

ous than the actual weaving. A long frame is used to stretch the warp threads to their full length, and these may then be treated with a size of starch or oil. Each portion of the design is then tied off with lengths of waxy fibre (Plate 34). The more elaborate the design, the more minute and painstaking the tying. Thick, coarse lines and large areas of one colour in the finished product are the hallmark of a careless or incompetent weaver!

When one set has been tied, the whole warp is taken off the frame and immersed in the first dye bath, usually light red or brown. Depending on the dyestuff, the threads may have to soak for several hours. Some colours have to be exposed to the dew (but *never* the rain) to properly set them. After the threads have been rinsed and dried, the warp is stretched on the frame again and the next part of the design is tied off. A dye bath of indigo will stain the selected portions blue-black. True indigo

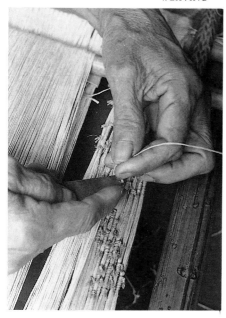

34. Iban woman tying off a design (Photograph Hedda Morrison).

blue can be obtained by untying portions which had been protected from the first dye by tying-off. A light blue, maybe the 'green-blue' used by the damsel in the song quoted above, is obtained by the use of diluted indigo decoction, or brief immersion.

A warp may be on the long frame for weeks or months. When it has been completely dyed, it is taken off the frame, carefully folded out, and transferred to the backstrap loom (Plate 35). The whole design can now be clearly seen on the warp threads.

Pua kumbu is woven with the weft thread slightly lighter than the warp, in the conventional 1 : 1 pattern. The backstrap loom is not stretched over a frame like the cottage loom. Its warp beam is attached to a solid support such as a main pillar of the longhouse. The breast beam is held by a strong, broad

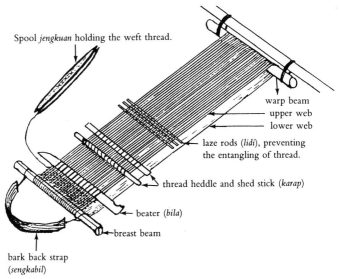

Spool *jengkuan* holding the weft thread.

warp beam
upper web
lower web

laze rods (*lidi*), preventing
the entangling of thread.

thread heddle and shed stick (*karap*)

beater (*bila*)

breast beam

bark back strap
(*sengkabil*)

35. Backstrap loom (By kind permission of Mrs Susi Dunsmore).

belt of tree bark which passes behind the craftswoman's back. Thread tension is maintained by the weaver's body weight. She may relax it a little while shooting the shuttle, then increase it by leaning back while she is beating-in (Plate 36).

Weaving used to be very much a part of an Iban girl's education. As a toddler she grew accustomed to the sight of her female relatives seated at their work. As she reached puberty, and had already shown some aptitude in making mats and baskets, she would be promoted to the loom.

A young girl's first task was simply weaving thread which her mother had prepared and dyed. Later she would be required to lend a subsidiary hand with the grating, pounding, and shaving of the botanical ingredients for dye-making. Finally, she would be initiated into the secrets of tying patterns. A respectable young woman had to have finished at least one full-sized *pua kumbu* to be eligible for marriage to a properly

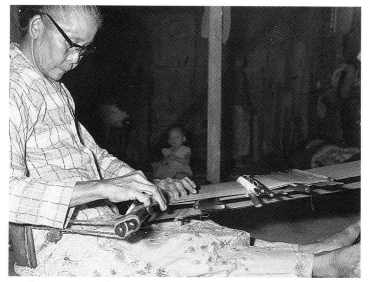

36. Iban woman at the backstrap loom (Photograph Sarawak Museum).

qualified young man, one who had obtained his first head trophy. The community took note of such developments. The women in the song fragment quoted above marvel at how soon a young girl has proceeded to the advanced patterns. But she was not likely to attain real mastery until she had reached middle age.

It is the older women who teach the young ones how to select patterns, and when to attempt the more ambitious, dangerous ones. A girl's first task is usually a skirt, decorated with leaf and creeper designs. Skirts may also contain reptile and insect patterns and occasionally the 'Man in the Moon', but not human figures proper. To include those, a weaver needs her ancestors' permission, which will be granted to her in a dream. The line between this world and the other is indistinctly drawn for a creative artist. A human figure in a *pua kumbu* is often referred to as a 'ghost', a 'dwarf', 'the Man in

the Moon'; any of these may represent an ancestor. Even after a weaver has received approval for using such designs, she must know how to protect herself lest she lose her skill or fall sick, or incur the gravest penalty of all—madness.

The comical dwarfs and elves depicted on *pua kumbu* may be benevolent or mischievous, according to circumstances. A weaver of stout heart, literally a 'strong soul', suitably fortified with the right kind of ritual protection, weaves them all safely; the over-ambitious novice suffers.

Jackets are sometimes woven or embroidered with whole friezes of dwarfs, but such garments would not be worn by an ordinary person, only by a cult leader or native doctor. Generally the human figure is reserved for *pua kumbu*, which will be hung on the walls, draped over an offering platform, or laid over the outstretched arms of a person ready to receive a present or a ritual object.

At the Gawai Antu, the festival for the souls of the departed, virtuous women present bowls of sacred rice wine to the community's heroes on folded lengths of *pua*. Newly captured heads used to be deposited on this precious textile. A native doctor is occasionally 'buried' under a wooden framework covered by *pua kumbu* so that he may descend into the underworld in pursuit of his dangerous calling. The Victorian description 'Iban blanket' for *pua kumbu* is functionally incorrect: few Iban would dare to sleep under one containing human figures unless they had a specific reason, such as trying to wrest a lucky omen or dream from their ancestors!

Handweaving is not nearly as common among Sarawak's Iban women as it used to be, but it has not stagnated. Today's experts, mostly middle-aged or elderly, obey the strictures and enjoy the privileges their ancestresses did. A few make use of shop-bought powder dyes, a short-cut frowned upon by most. New designs are still not attempted without the traditional sanction of a dream, though subjects may reflect the changing times.

For example, a beautiful length of cloth, woven by a police sergeant's wife, shows 'Traffic Cops Waving Flags'. Confrontation in the 1960s brought helicopters to some remote areas, and rifles and various kinds of aircraft may be found incorporated in the scroll and chevron patterns of more recently made *kain kebat*.

Malay Weaving

The Sarawak Malays, mostly coastal folk, used to produce cloth for their own use in the past although the weaving of fine stuffs was mostly the preserve of the rich. Margaret Brooke, the second White Rajah's consort, occasionally shared in the doings of the upper-class ladies of Kuching, and in her book, *My Life in Sarawak* (1913: 30), describes how she attempted to learn to weave in the 1870s: 'To help to amuse me and to while away the time,' she writes, 'Datu Isa [wife of one of the most senior Malay chiefs] and her maidens brought ... a great loom prepared with golden and silk threads, to teach me how to weave these brocades. The loom was so large that one could sit inside it. A sort of pad made of wood supported one's back and acted as a lever with planks at one's feet to keep the thread taut. A shuttle in each hand threw the thread backwards and forwards in the usual manner, but the effort of keeping the thread tight with one's back and feet was a somewhat fatiguing experience. I must confess I never achieved many inches of these cloths. ...' This was obviously a backstrap loom with side frames, its heddle rods probably lifted without the noble weaver's notice by the maidens in attendance.

Almost the only cloth woven nowadays is *kain songket*, a rich brocade of one colour with silver or gold thread, sometimes called *kain Brunei*, a historical clue to the craft's origin (Colour Plate 20). The piece is of uniform length, patterned with a sprinkling of isolated stars, flowers, or a loose geometrical

design over the main part, and an intricate panel in the centre or at one end, known as the 'head' of the cloth, where the weaver displays her ingenuity (Plate 37). It may be composed of stylized flower and leaf designs or it may be an elaborate zig-zag.

Sarawak was something between a colony and an outlying garrison of the Sultanate of Brunei in the early nineteenth century. The more enterprising noblewomen resident there were expert weavers, and it is possible that patterns were passed on to the upper-class ladies of the local population. Alternatively,

37. Malay *kain songket* showing the 'head' of the cloth (Photograph Sarawak Museum).

these weavers may have copied the designs of *songket* lengths which came into their hands as presents or by way of trade. Handwoven cloth is destined to be worn as a sarong, a long tucked skirt locally called *kain tapeh*, overlapped in front and tucked into one side at the waist. The 'head' is worn in front by women. Men also wear sarongs kilted over their traditional dress of loose shirt and long trousers. In that case, the brocaded cloth is folded in half lengthwise and the panel is worn at the back. Personal taste and ingenuity are displayed in the way the tuck is pleated, from a simple firm underhand roll to spreading fan or flower styles. Although *kain songket* is often used by both men and women for formal functions, the usual reason for ordering a length of it is to outfit a wedding. Proud parents like to see their daughter and her groom dressed in matching outfits on the great day of the *bersanding*, the sitting-in-state of the bridal couple.

The modern weaver makes use of a cottage loom with pedals for lifting the threads in the sequence demanded by the pattern, a hand- or roller-shuttle, and a wire comb beater attached to the loom with a hinge.

The Malay weaver today has most likely learnt her craft from her mother or from another elder relative. Unlike the young Iban girl, she is allowed to use any pattern she likes, although in practice she will make the patterns her teacher taught her, over and over again.

Bark Cloth

Bark cloth was widely used throughout Sarawak when cloth was scarce. For instance, during the Japanese Occupation (1941–5), when practically no new cloth was imported for four years, many villagers brought their bark beaters out of the rafters where the humble instrument had been gathering dust and revived the craft. Not only clothing, but also blankets and even

mosquito 'nets' were made of this stiff material.

But even before this emergency, some tribes never did much weaving and generally relied on trade with their neighbours for good clothing. The Iban, arguably Borneo's most skilled weavers, used bark cloth for making stout war coats and rough wear, or for padding woven or beaded garments.

To produce such cloth, the outer bark is peeled off a suitable felled tree first, and the inner layer stripped off in sheets as large as possible. These are then beaten with stone or wooden mallets, depending on the material's thickness and the craftsman's skill.

Although bark cloth is thick and fairly warm, and firm enough to give its wearer some protection against blows and thorn scratches, its disadvantage is that it tends to tear length-

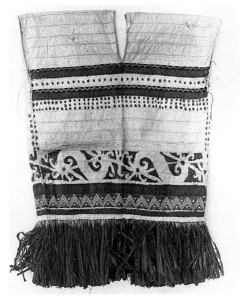

38. Kenyah bark jacket with stencilled and darned decorations and fringe (Photograph Sarawak Museum).

wise. To prevent such damage, as well as to beautify the garments, bark clothes used to be artistically darned all over, at right angles to the direction of the natural fibre, using straight lines, blocks of stitches regularly transposed, triangles, and rhombs (Plate 38). Often coloured threads unpicked from shop-bought cotton lengths were used, and care was taken to edge arm and neck openings of the bark garments with imported cloth.

Paint was often used to decorate the paper-like surfaces of bark cloth, especially by tribes used to the art of wood painting. Among the people of Central Borneo, the motifs permissible for each wearer were determined by social status.

Another form of decoration was stencilling. The apron-like skirts common among Kenyah and Kayan ladies used to be lavishly decorated with stencilled-on designs. Sometimes the skirt piece was of bark cloth, while the edges were made of patterned cotton bought from itinerant traders or downriver bazaars. Pieces of cotton, artistically cut out with the ubiquious long-handled knife, were stitched over the bark cloth, especially along the lower edges. For festival wear, the pattern was further embellished with bead embroidery.

Bark cloth is practically never used for clothing nowadays, and it is doubtful whether more than a few dozen people in Sarawak have handled a bark mallet within the last ten years. An exception is the manufacture of traditional clothing worn at cultural shows or costume competitions.

One other use remains. Bark cloth strips are still used as the carrying belts for many kinds of baskets. However, the modern farmer's wife who makes bark carriers for her baskets saves herself the tedious labour of beating the material by simply turning the strips through a rubber mangle designed for pressing sheets of raw rubber. This treatment produces straps of acceptable strength out of previously air-dried and then carefully moistened bark, with a pretty diamond pattern embossed.

6

Common Motifs

Early he awakens, still drowsy, confused
He props himself up to sit upright
Looking around on his sleeping mat
The mat with designs like a human face
The mat with designs like an endless snake
The mat made like the changing shapes of the clouds.

Kenyah courtship song[1]

MUCH has been written about the class system of Sarawak's *Orang Ulu*. The aristocracy claimed closer relations with the spirit world; each high-class individual had a personal tutelary deity which protected him first and, by extension, his tribe. Disobedience to a leader would have been equivalent to disobedience to the spirits. However, the advent of education and Christianity, an upsurge of indigenous religious revival, and greater physical mobility of the individual have changed many of the once rigid distinctions, and drastically simplified the complicated system of ritual and taboo that used to shore up the position of the upper-class Kenyah, Kayan, Kelabit, and other Central Borneo peoples. Today's descendants of the aristocracy are more reserved about flaunting status.

Similarly, while the old designs in Sarawak crafts have lost none of their beauty and deserve to be respected, they no longer denote class distinction in the absolute way they once did.

The following is a summary of what *was* once vitally important to preserve balance and harmony within isolated com-

[1]Rubenstein, op. cit.

78

munities (which allowed minimum leeway to the rebellious soul) as it applied to artistic expression in beadwork, paintings on bark cloth and on wood, on imported textiles, and on anything else that a lively and inventive mind might choose to decorate.

'The Dayak's artistic instincts,' Nieuwenhuis wrote in 1907 (11: 235), 'are much more developed than they are among more advanced peoples. The majority of men and women are capable of ornamenting articles in common use, with none but the simplest tools at their command and no instruction other than watching their elders. . . . ' Indeed, it was from watching their elders that they learnt the techniques and it was from watching their elders that they learnt who might use which ornamental design, and why.

Among the Kayan, Kenyah, and Kelabit, the full figure human motif was strictly reserved for the aristocracy. It might be depicted standing or squatting, displaying genitalia or arrayed in breeches, but it was only to be found on the belongings of the upper class.

Aristocrats could build their roofs higher and they had human figures and the vital 'tree of life' painted on the front walls of their sections of the longhouse (Colour Plate 21). This tree shows how the 'higher' animals–hornbills, humans, and leopards–belong to the topmost branches, the main stems. The beautiful murals that enliven the inside walls of some Kenyah and Kayan longhouses diminish in richness from the centre of the house towards both ends–exactly reflecting the gradation of the social orders.

The respectable middle classes could make use of modified half-figures, masks, less ostentatious animals like the dog in its many adaptations, the lizard, some insects, and plants. Further down the verandah the walls, if they were painted at all, featured scrolls and lines. The dwellers here were the lowest class,

probably too exhausted from work in the masters' fields to do much painting after curfew.

A Kelabit baby carrier embellished with a curly haired, curly handed, and curly toed human figure sheltered a tiny sprig of the aristocracy. Larger beads, hawks' bells, and animal teeth were attached to the upper rim of this back-basket carrier, partly to soothe the baby with their tinkling and partly to document his status—in some areas the use of leopard teeth was restricted.

A middle-class baby could take his first peep at the world from a basket decorated with a human face, stylized animals, or beautifully involuted scroll designs. The family might be wealthy enough to cover the whole object edge-to-edge in beadwork. Down the socio-economic scale is the baby carrier of fine basketry with just a panel of bead embroidery in the centre, or simply a softly lined basket of split *rotan* or bark.

Class followed a man from the cradle to the tomb. A bereaved aristocratic family could spare no expense to build a repository or an ossuary (burial customs vary) befitting the deceased's status. Apart from the huge feasts they were obliged to give as part of the mourning ritual (and for the provision of which they could tax the lower orders), they had to call in the best artists in the region to build the tomb. By feasting and paying the artisans royally it was ensured that the monument would be a work of art, guarded on the roof-top by leopard or dragon figures and at the four corner-posts by the characteristic Borneo interior 'dog' with its wide open jaws, teeth, and ears, curling into and around each other.

To stint at such a time would be unthinkable. Beside the vague feeling that an insulted ghost might make trouble, censorious neighbours ensured an outstanding effort. Even a low-ranking craftsman could be engaged on an aristocrat's monument if he was really good. In the event, the bereaved family had to present him with special gifts of iron to strengthen his soul, and

beads to preserve his eyes from so much class!

Tombs and burial poles combine painting and woodcarving, but here, too, the choice of motifs used to be of paramount importance. The highest and the most beautiful–human, hornbill, and leopard images–were for the aristocracy. The middle class was entitled to faces and lower-ranking animals. The lowest or slave class were not usually deposited above ground but were simply treated to earth burial.

Two Common Motifs

THE HUMAN FIGURE

The full figure or face of the human being is used by every Sarawak group for purposes of protection from ill luck and evil spirits. The Orang Ulu have developed it to a high standard in painting; the Iban in weaving.

The human figure on *ulu* painting or in beadwork may be standing upright, but is more commonly squatting, arms and legs part of a zig-zag pattern to which others are linked. The eyes are always open, the mouth occasionally shows teeth, and the ear-lobes are long and often incorporated into the pattern formed by other decorative elements–the figure may stretch its arms through them!

If a face only is used, stylization may compress some features and expand others to fit the space available. The eyes are always stressed; on a shield, they are enormous. They may be painted or carved with care so that they are clearly visible, for it is their function to strike terror into the enemy's heart.

The human figure used in art may show exaggerated genital organs, partly to frighten evil spirits, and partly to protect the owner and wearer of the articles. Nudity, except in very small children, is not acceptable in Sarawak societies. Adults may look 'half-naked' to the casual observer but, in fact, people are

most particular about preserving the proprieties. Images of human private parts are potent protective magic. Nieuwenhuis, for instance, considers the curly decorations on top of Kayan swords to symbolize the female labiae and carved decorations on doorsteps to represent the external generative organs of both sexes (1907, II: 252–6). Their presence at the only entrance to a family room effectively blocks entry to evil spirits.

With regard to clothing embellished with human figures, there are different practices between the people of Central Borneo and other native tribes. A Kayan lady's bead jacket could show friezes of displayed female figures, symbolic of her slaves. Provided the wearer was of sufficient rank, the human figure was not only suitable but necessary to uphold his or her dignity.

The Iban felt quite differently about this. The most commonly worn piece of clothing, the woman's skirt, practically never had recognizable human figures on it. The few jackets decorated with dwarfs, spirits, and ancestors were worn by men or women of exceptionally strong soul–spirit doctors— who could *stand* such a challenge.

Pua kumbu often have very beautiful human figures on them, with the males displayed, the females dressed in skirts, and some wearing tall head combs (Plate 39). These were, however, not used for sleeping under except on ritual occasions, for instance when a cult leader had to be symbolically 'buried' in the execution of his healing duties.

The rare Iban bead jackets are crafted in a technique that makes the working of graphic patterns difficult. (Some such artefacts labelled 'Iban' in museum collections could be of Maloh origin.) The Iban and Bidayuh freely used images of humans and other living things in carving. They painted them on their shields and admired them on ceramic jars, but they neither wore them nor had them tattooed on their skins.

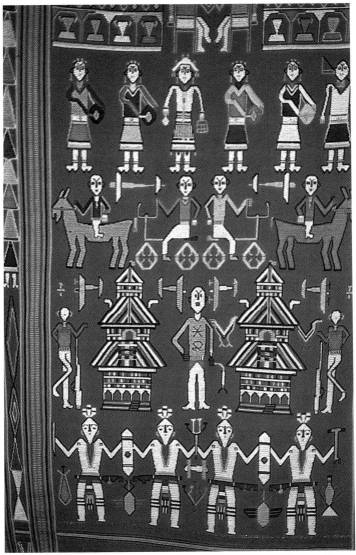

39. A post-War Iban *pua kumbu, sungkit* technique, showing full human figures.

ASO 'DRAGON-DOG'

The dragon–dog, a quadruped or reptile body with a square head, is the most distinctive of all Borneo motifs. It has protuberant eyes and its mouth, which is usually studded with teeth, is always open, its jaws and fangs curling upwards and downwards. In relief carving or painting the fangs may interlace with each other or with the next part of the design, becoming stylized and involuted almost beyond recognition. Carved in the round (as when supporting food platters and tables), surmounting structures, or embellishing sword hilts, the *aso* shows the dragon's features more than the dog's, with wide staring eyes, angular head, and rudimentary or developed horn or horns.

Real dogs are ever present before Sarawak's craftsmen in the form of the longhouse curs. They are not artistically inspiring creatures on the whole, and it is not surprising that no old *aso* figure looks more than vaguely canine. Indeed, the body of a full *aso* in painting or bas-relief carving is more reptilian than quadruped. It often has forelegs and then squats and undulates into what could be either legs or a snake tail.

Although prototype dragons (*naga*) are available for inspection on the best Chinese stoneware jars, much valued by all indigenous tribes, they are practically absent from Borneo folklore; few people know that *naga* can fly, breathe fire, and the like. However, the name—derived from Sanskrit—is common to all tribes, and is probably from the vernacular Malay the upriver traders have been speaking over the last few hundred years. The jar decorations may well be considered the model for the *aso*, the dragon possibly having ousted a now-vanished indigenous Bornean dog figure which survives only as part of a name.

A century of European influence and contact has modified some of the traditional designs. A community used to sitting

84

on mats on the floor, although the highest-ranking member may have a beautifully carved seat 10–20 cm high, does not need tables. Yet among the most prized productions of the Berawan and some other people of the Baram River system is a hardwood table supported by four open-mouthed dragon-dogs (Colour Plate 22), all worked in one piece of noble hard-wood. This model is generally credited to a suggestion by Dr Charles Hose, Resident of the Baram for many years.

Many of Sarawak's carvers now work for the tourist market, producing domestic, working, and travelling groups, animals, model longhouses, or boats, in fact anything that will sell (Plate 40). Many of these designs are derived from Berawan models. The Berawan of the Tinjar River must be amongst Sarawak's most accomplished woodcarvers, embellishing every article of daily use and every part of their dwelling with dec-orations.

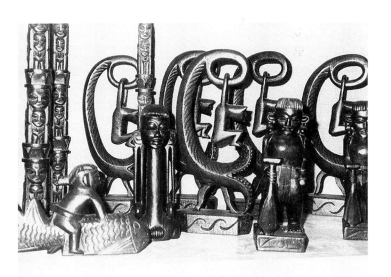

40. Modern woodcarvings for the tourist trade.

'Mother and child' is a favourite among statue carvers, as is 'Man carrying Monkey', 'Monkeys Climbing'–which features the animals with linked arms swinging free from a loop of the tree–and 'Man and Monster'. A twisted, gnarled root or branch is used as the support for a multi-tiered coffee table, each plane made of a slice of tree trunk. The *tapang* tree is a favourite, as a section of its trunk shows up the distinctive blood-red heartwood and the near-white outer mantle. Such artefacts are commonly offered for sale on the 'five-foot ways' of Sarawak's larger towns.

Other craftworkers are beginning to produce surplus articles for sale, too. State and Federal Government agencies are actively fostering the development of a cottage industry that keeps country people gainfully employed, and preserves traditional skills. Many women make basketry and mats for sale, often miniatures of popular hats, household implements like the winnowing tray, single designs taken out of a mat pattern framed as wall hangings. Even the weavers are following suit, turning out a piece of *kebat* weaving about the size of a bath towel, with one large figure in the centre and a few ornamental zig-zag lines down the sides.

What distinguishes these artefacts and statuettes from older, traditional models is their style. The basketry and weaving are worked with an eye to fast, plentiful production. New carvings are accurately observed, naturalistic renditions of human and animal life, the work of a man who carves for the fun of it or to make a living unhampered by ritualistic considerations.

Appendix: Materials

Woodcarving

BELIAN (*Eusideroxylon zwageri*), very hard, durable wood, turns dark with age; difficult to work, liable to split.

KEMUNING (*Murraya* spp.), good quality hard wood, suitable for making sword hilts.

MEDANG (*Lauraceae* spp.), red-brown light wood, contains fragrant resin that repels insects; suitable for making string instruments, masks and similar articles, but not food containers.

PELAI (*Alstonia spathulata, A. angustiloba*), medium-sized fairly common tree yielding soft white wood; not very durable.

TAPANG (*Koompassia excelsa*), very tall straight hardwood tree; wood takes on a fine polish and is used for food dishes, furniture, blowpipes, and weaving utensils.

Weaving

THREAD

Plain cotton yarn can be bought in some shops in Kuching and in the larger market towns; it is also available dyed in strong colours. Although weavers complain that it is expensive, and at times in short supply, they still prefer buying it to processing their own jungle cotton, very time-consuming work which has hardly been done since the Second World War. In fact, few craftswomen would still know how to do it, or have the necessary implements at hand.

For *anyam* and *sungkit*, some weavers use thin embroidery cotton, which makes for a rather stiff finished product.

TAYA (*Gossypium* spp.), fairly large bush, commonly found in clearings around older longhouses. Its seed capsules burst open to reveal the fibre, rather like *kapok* but with a longer staple. *Taya* is picked, beaten, carded, and spun like ordinary cotton.

DYESTUFFS

ANGSANA (*Pterocarpus indicus*), sticky sap; yields a reddish colour.

ENGKERBAI (*Stylocoryne* spp.), tall bush. The leaves are picked, chopped, boiled, and mixed with lime to yield a pinkish-red dye. The yarn is put into the infusion while it is still warm, and energetically pounded and squeezed for about half an hour.

ENGKUDU (*Morinda citrifolia*), root skin of a tree. It is boiled and mixed with lime to make a rich brown-red dye.

ENTEMU, *kunyit* (*Curcuma* spp.), wild tumeric; yields a strong orange-yellow dye. The root is pounded or grated, mixed with cooked rice and lime, and the resulting paste is kneaded into the yarn. It must be well rinsed off with fresh water.

PILING (*Abarema* spp.), tree; valued for the brown dye obtained from its leaves. These are chopped, boiled, mixed with clean clay, and then applied to the cloth or yarn to be dyed. Some dying is done in shallow wooden troughs; *piling* is a slushy paste that is usually applied on a mat. The material has to be squeezed and kneaded well, and must be rinsed with many changes of fresh water after the desired shade has been obtained.

TARUM (*Marsdenia tinctoria*), creeper related to the indigo family; yields a blue dye. *Tarum* is chopped, steeped in water, mixed with lime, and areated by pouring from one vessel into another. The liquid actually looks yellow, but it stains materials blue. When applied over red or brown, *tarum* produces a deep blue-black.

TENGAR (*Ceriops* spp.), bark. It is pounded and then steeped in boiling water to make a brown dye.

Bark Cloth

IPOH (*Antiaria toxicaria*), the Upas Tree of legend; it did not make every living thing that approached it fall down dead, though one potent blowpipe poison is decocted from its sap. The outer bark is stripped off, the inner bark pulled off in large sheets and then pounded into a high-quality white bark cloth.

TEKALONG (*Artocarpus elasticus*), a rougher, more common bark. Whole sheets of it could be used to make temporary walls, or shaped and stitched together into makeshift boats. The brown carrying straps of many Sarawak baskets are made of *tekalong*. If used to make clothing, the outer bark is peeled off and the inner, softer layer used.

Mat-making and Basketry

MATERIALS

BEMBAN (*Donax arundastrum*), a reed collected from swampy places. The stems are used to make sleeping mats and sometimes baskets. It is harvested green, dried and stored for future use, but has to be soaked before it can be woven.

BULOH (*many kinds*) (*Bambusa* spp.) The shiny outside skin of bamboo is used for making small to medium-sized baskets and small mats. Modern use is in the manufacture of table mats, purses, etc. which are sold as souvenirs.

MULONG (*Metroxylon sagu*) The sago leaf is split to remove the stem and then split into the outer and inner layer. It is fairly brittle and best not woven into small patterns. Uncut leaf sections are used to make fans, sun hats, and food covers.

NIPAH (*Nypa fruticans*) The soft fronds of this palm are opened and the young leaves used for making rough mats or cases for steamed rice cakes.

PANDAN (*Pandanus* spp.) The leaves are split to remove the thick rib and rough edge. They are folded or further split to the correct width, depending on the amount of strength required of the finished article. Even multi-layered *pandan* is not very durable.

ROTAN (*Calamus* spp.), a creeping palm; the favourite material for strong mats and baskets. The creepers are harvested by pulling them down, a difficult job as they are thorny. They are then stripped, cut into convenient lengths, and brought home for further processing. For really fine baskets, only the outside skin is used. *Rotan* may be bought in most bazaars and towns of Sarawak.

TENGANG (*Lygodium splendens*), a creeper that yields a fine

tough fibre suitable for decorative lashing. Its main use is for threading beads and making beadwork. Pineapple fibre is also used for this purpose.

COLOURING MATTER

The usual textile dyes can all be used for staining basketry materials. In practice, as most are shades of red, pink, or brown, they would not add much to the natural buff and brown of the reeds, creepers, and dry leaf sections.

For black, soot is rubbed into the mat-making material. If prepared *tarum* (indigo) dye is handy, it can be used to stain reeds and creepers blue-black. In some places, a black sediment is found near river banks. Basketry materials may be buried in this for a few days to stain them black.

For red, ripe *rotan* berries are boiled in water until they disintegrate. A waxy red substance floats to the top of the water, and this is collected on a stick when it is cool, and rubbed on the *rotan* or bamboo as required. Rotan seed paste is the 'Dragons' Blood' of medieval commerce.

Painting on Wood and Bark Cloth

For black, soot is applied in a medium of oil or sugar-cane juice. Large areas used to be painted with the fingers or the whole hand; fine work was done with a chisel-shaped stick. The paintbrush was introduced by the Chinese traders and is very commonly used nowadays.

For red, iron oxide or red earth is applied in a medium of oil or sugar-cane juice. Rotan seed red is also used for painting on wood and on bark cloth.

For white, powdered lime is applied in a medium of oil or sugar-cane juice.

Where oil or other ready-made paints are available, they are commonly used nowadays.

Select Bibliography

Bock, Carl, *Reis in Oost en Zuid-Borneo*, Martinus Nijhoff, s'Graven-hage, 1881.

Brooke, Margaret (The Ranee of Sarawak), *My Life in Sarawak*, Methuen & Co. Ltd., London, 1913; reprinted by Oxford University Press, Singapore, 1986.

Chin, Lucas, *Cultural Heritage of Sarawak*, Sarawak Museum, Kuching, 1980.

Christie, Jan Wisseman, 'The Santubong Sites of Sarawak', *Sarawak Museum Journal*, Vol. 34, No. 55, 1985.

De Barros, J., *Da Asia*, Lisbon, 1777.

Earl, G., 'Trading Posts in the Indian Archipelago', *Journal of the Indian Archipelago*, 1850 and other issues, Mission Press, Singapore.

Harrison, T. and Jamuh, G., 'Niah–The Oldest Inhabitant Remembers', *Sarawak Museum Journal*, Vol. 7, No. 8, 1956.

Harrisson, T. and O'Connor, S., *Prehistoric Iron Industry in West Borneo*, Cornell University Press, Ithaca, 1969.

Heinze, Susi, *Art Teaching for Primary/Secondary Schools* (3 vols.), Borneo Literature Bureau, Kuching, 1969.

Hose, Charles and McDougall, William, *The Pagan Tribes of Borneo*, Macmillan, London, 1912.

Low, Hugh, *Sarawak–Its Inhabitants and Productions*, London, 1848.

Mohd. Kassim Hj. Ali, *Masks of Sarawak*, Muzium Negara, Kuala Lumpur, 1983.

Morrison, Hedda, *Sarawak*, Times Publishers, Singapore, 1982.

Nieuwenhuis, A. W., *Quer Durch Borneo*, Vol. 11, E. J. Brill, Leiden, 1907.

Richards, A. J. N., *An Iban–English Dictionary*, Clarendon Press, Oxford, 1981.

Rubenstein, Carol, *The Honey Tree Song–Poems and Chants of Sarawak Dayaks*, Ohio University Press, Athens, Ohio, 1985.

Sarawak Museum Journal, various issues, 1911–87.

St. John, Spenser, *Life in the Forests of the Far East*, Smith Elder & Co., London, 1862; reprinted by Oxford University Press, Singapore, 1986.

Schwaner, C. A. L. M., *Borneo*, P. N. van Kampen, Amsterdam, 1853.

Zainie, Carla, *Handicraft in Sarawak*, Borneo Literature Bureau, Kuching, 1969.

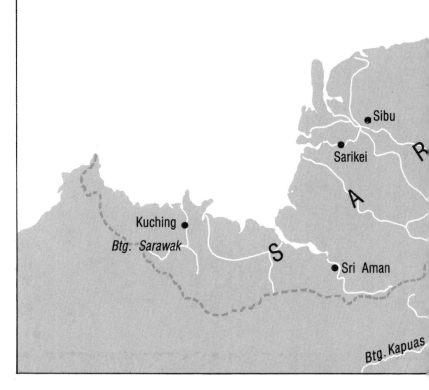

SARAWAK

SOUTH CHINA SEA

Sibu

Sarikei

R

A

Kuching

Btg. Sarawak

S

Sri Aman

Btg. Kapuas